THE NEW ALPHABET SCHOOL Edited by Olga Schubert, Gigi Argyropoulou, Mahmoud Al-Shaer, and Rahul Gudipudi, with contributions by Vinit Agarwal, Edna Bonhomme, Chto Delat, Gilly Karjevsky, Agata Kowalewska, Diana Lelonek, Nikolay Oleynikov, Špela Petrič, Alessandra Pomarico, Irit Rogoff, and Anaïs Tondeur

T0054293

The New Alphabet School

Edited by
Olga Schubert, Gigi Argyropoulou, Mahmoud Al-Shaer,
and Rahul Gudipudi

The New Alphabet School

Practices of Knowledge Production in Art, Activism, and Collective Research

How can an institution be shifted—an institution that was created to represent cultures and practices from outside Europe—into a place that creates conditions of solidarity and exchange? How might institutions be ephemerally transformed through artistic, curatorial, and activist practices?

Haus der Kulturen der Welt (HKW) was founded in 1989 as a venue for the arts from outside Europe in the former Congress Hall, whose opening in 1958 communicated a manifesto for freedom of thought and expression in the context of the Cold War. Resting on the notion of "cultural regions," such as China, the Middle East, Iran, India, Central Asia, and others, HKW was supposed to offer a Berlin audience access to cultural productions from around the globe.[1] Through collaborations with the various regional curators, however, different perspectives entered the House, ones that refused to be colonially labeled as representative of any particular cultural identity. A post- and de-colonial discourse thus grew, raising structural questions of resistance, counterculture, and knowledge practices in the arts, challenging the Western canon, and creating new alliances and solidarities among former colonized countries.

The curatorial team at HKW reacted to this development by departing from the culturalizing perspectives of regions and instead started to develop long-term research projects that would raise questions of planetary transformation or of the possibility of decentralizing hegemonic sign systems, such as alphabetical writing or the binary code. The project *The New Alphabet* (2019–22), initiated by HKW's director, Bernd Scherer, emerged.

When Bernd Scherer invited us to create *The New Alphabet School* in 2019 within its framework, we were therefore tasked with

1 For an extensive historical discussion of HKW's exhibition history see Annette Bhagwati, "Representation of Culture(s): Articulations of the De/Post-Colonial at the Haus der Kulturen der Welt in Berlin," in Margareta von Oswald and Jonas Tinius, *Across Anthropology: Troubling Colonial Legacies, Museums, and the Curatorial.* Leuven: Leuven University Press, 2020, pp. 337–60.

the somewhat heavy undertaking of creating a different infrastructure in an institution and an architecture with a difficult legacy. That's why the first invitation the School sent out was to attend a five-day winter school called the "(Un-)Learning Place," where Berlin-based collectives would offer workshops to eighty international participants, offering insights into their activist and artistic practices of knowledge production outside of established institutions and academies.

Offering five different "strands": "Untranslatability of Translation," "Against the Digital?," "(Un-)Archiving," "Molecular Bodies," and "Spaces of Theory"—in parallel with an extensive festival program entitled *The New Alphabet Opening Days*, with numerous panels and performances from renowned artists and intellectuals—the "(Un-)Learning Place" commenced as a gathering of practitioners that would exchange different practices of engaging with archives, institutions, bodies, technologies, or languages in a transformative way. However, in some ways, it again rendered participants from all over the world as students or consumers of a certain knowledge canon that it was offering, and this did not fulfill the wishes of many of its participants who wanted to actually have time to organize, identify, and address the power struggles and hierarchies they found themselves in. Reflecting on her attendance of the "(Un-)Learning Place," New York-based anthropologist Yayra Sumah wrote in her essay, "The Work before the Work," for *The New Alphabet School*'s blog:

> We had convened, many of us traveling from places which academic discourse has often (contentiously) theorized as the 'Global South' to a space called '(Un-)Learning Place,' a series of workshops led by local artist-run research platforms, academic communities, and activist organizations in Berlin. The aim was to enable the participants to share their ideas and intertwine strategies for unraveling colonial modalities, epistemologies and languages. Very soon however, it became clear that instead of an emergent and co-creative process of discussion [...] we found ourselves trapped within a historical pattern of institutional paternalism which was colonizing us. This pattern emerged when for example, within the workshops I participated in, power struggles and conflicts began to take place between workshop leaders, administrators and participants. [...] In brief, we had not all worked to unlearn patriarchal modes of relation in order

to form a starting point or common ground from which to build
our collaboration. We had stepped into the arena of collabora-
tion ready, but in reality, unprepared to do the work.[2]

This quote shows that collaborative work is not something that can
simply be demanded, expected, implemented, or decided upon. The
foundations must be laid by acknowledging the many different histo-
ries, different vulnerabilities, and different imaginaries, especially in
asymmetrical relationships within institutional structures. And this is
the task *The New Alphabet School* continued to work on, continually
experimenting with different structures and modes of collaboration
and support.

After the "(Un-)learning Place" had convened, all eighty par-
ticipants were invited to come forward should they be interested in
hosting a subsequent gathering of the School from the places in
which they work. Each gathering was to be dedicated to a practice of
knowledge production, situated in the location from which the in-
quiry was going to depart. HKW sought local partner institutions
and was to produce the gatherings on site in various locations. With
the help of the participants who came forward—so becoming edi-
tion curators—speakers and artists were invited for an opening
night. The main focus of and contribution to the program, however,
came from other members of *The New Alphabet School*—the so-
called *Unlearners*.

With internal calls for new members of *The New Alphabet School*,
HKW asked all participants to propose workshops for the gatherings,
five of which would be selected by an editorial board who would travel
to the respective destinations of the gatherings. After three years, we
still constitute the editorial board: Mahmoud Al-Shaer, based in Rafah,
Palestine, editor of *28 Magazine*, a local literary print and online maga-
zine that was named after the twenty-eight letters of the Arabic alpha-
bet, evoking pan-Arabic solidarity and literary exchange in spite of the
locked-in situation; Gigi Argyropoulou, a researcher, writer, and cura-
tor based in Athens, who was part of the group that initially squatted

2 Yayra Sumah, "The Work before the Work," *The New Alphabet School* blog
 (December 12, 2020), https://newalphabetschool.hkw.de/the-work-
 before-the-work/, accessed July 8, 2022.

Embros Theater in 2011, among other actions during the years of the financial crisis, in order to develop grassroots strategies that reimagine and create collective, self-organized, social/cultural institutions; Rahul Gudipudi, a researcher and curator from Bangalore who was involved in producing modes of collective practice and research with Nodi Collective and with The Story of Foundation, both of which aim to develop life-long and life-wide experiential learning practices and reflect on the place of the arts and culture in co-developing such opportunities in public spaces; and Berlin-based cultural organizer Olga Schubert, the organizer of the project on behalf of HKW.

The New Alphabet School editions that emerged out of this process were: TRANSLATING and SITUATING at HKW in Berlin; CODING in New Delhi; CARING in Berlin and Hohenlockstedt; HEALING, online and in Dakar; INSTITUTING in Athens; SURVIVANCE in Bissau and Porto; TRANSMITTING in Rafah and Berlin; COMMUNITY-BUILDING in Havana and Berlin; FERALIZING in Warsaw; and finally, COMMONING in Berlin. The programs and workshops that constituted each of the gatherings were always open to the public, and anyone who attended could become a member of *The New Alphabet School* and hence receive calls to propose workshops.

However, the amount of work needed did not become smaller but, rather, larger over the course of these encounters. School members learned of injustices that expanded their understanding of the myriad facets of the problems at issue: the murder of a community leader in Bonaventura, Colombia, over his efforts to fight for the homes of the local Black community against massive investment companies (SITUATING); the politicized instrumentalization of surveillance technology in India, used across political parties but particularly by the incumbent government, for incursions into body politics, large-scale illegal data gathering, and unparalleled internet shutdowns (CODING); the global ingratitude shown towards care workers, made increasingly visible by the pandemic (CARING); the painful impossibility of healing colonial wounds in the education system in Senegal (HEALING); the structural defunding of institutions and the subsequent need for self-organized infrastructures in Athens and beyond (INSTITUTING); the marginalization and exploitation of Indigenous communities in Guinea Bissau, Australia, and elsewhere (SURVIVANCE); the hardships encountered while trying to connect with a wider canon of literature in spite of the conditions in Palestine

(TRANSMITTING); the persecution of activists and artists by an authoritative government in Cuba (COMMUNITY-BUILDING); and the deprivation of women and LGBTQ+ rights and the war on Ukraine (FERALIZING). On top of all this, the above-mentioned power asymmetries among members of *The New Alphabet School* continued to pose enormous challenges to collaborative and community-based work across so many different perspectives and in the context of an institution such as HKW.

This *work* is urgent and needs to be continued.

This book cannot give an overview of the voices present in *The New Alphabet School* project. A better source for these reflections, recountings, and reportings is the School's blog: https://newalphabetschool.hkw.de/. Instead, as the editorial board, we decided to invite writers who either held a lecture within the framework of *The New Alphabet School*, curated one of its gatherings or editions, or who contributed a workshop to specifically look at the questions that *The New Alphabet School* poses: Is it possible to imagine multifarious fields of ways of speaking, knowledge production, and learning practices beyond one universal matrix? Can common reference points and collective action be enabled without a potentially hegemonic center? How can knowledge be both locally situated and, at the same time, produce a new kind of universality? In what ways can traces of "doing otherwise" form current and future practices? How do practice-based, militant, and emergent knowledges mutate and disseminate? What other trajectories of knowledge or "know-how" might they form?

What we received were seven wonderful essays and conversations, offering a meta-reflection on methodologies of collective, decentralized knowledge production in the arts: Irit Rogoff on commoning research; Gilly Karjevsky on collective auto-theory; Edna Bonhomme on female Black artists addressing a collective female Black audience; Vinit Agarwal on the film *Oyoyo* as an archive of the politics of friendship; Nikolay Oleynikov from Chto Delat on altars as non-monumentalizing sites of memory; Alessandra Pomarico on radical pedagogies; and Diana Lelonek, Špela Petrič, and Anaïs Tondeur interviewed by Agata Kowalewska on feralizing as an artistic practice. These writings are by no means an end to this work, nor should they be. Rather, they mark a moment of addressing some reflections that we, the editorial board, and these authors have had during our time

spent with *The New Alphabet School*—reflections that can perhaps become places for future explorations.

We want to thank all contributors to this publication, all members of *The New Alphabet School*, and all colleagues at HKW for this amazing journey. Especially heartfelt thanks go to Elisabeth Krämer, Caroline Adler, and Jessica Paez from HKW, each of whom coordinated this project for large parts of its journey. We thank the managing editors of this book, Savannah Turner and Martin Hager.

Thanks also to all *The New Alphabet School* edition curators: Sascia Bailer, Boris Buden, Filipa César, Maya El Zanaty, Jacob Eriksen, Karin Harrasser, Gilly Karjevsky, Agata Kowalewska, Alessandra Pomarico, Esther Poppe, Juliana Rabelo, Abdourahmane Seck, Yayra Sumah, Rosario Talevi, and Kostas Tzimoulis.

Our thanks extend to the workshop conveners: Maiada Aboud, Laeïla Adjovi, Mohammed Alzaqzouq, José Luis Aparicio Ferrera, Aparecida Arguello, ASSET Production Studio, Associação das Prostitutas de Minas Gerais (APROSMIG), Julia Ayerbe, Maree Bashir, Kamran Behrouz, Louis M. Berger, Edna Bonhomme, Ahmad Borham, Ana Bravo Pérez, Loren Britton, Daphne Brunet, Chto Delat, Tomás Cohen, Vadinho da Costa, Ivy Ashleigh Da Gorriti, Christine de la Garenne, Marinho de Pina, Isabel de Sena, Greta di Girolamo, diffrakt – centre for theoretical periphery, Andreas Doepke, Teresa Dillon, Each One Teach One (EOTO) e.V., Raed Eshneoura, Tomás Espinosa, Sagal Farah, Susana Ferreira, Chiara Figone, Corinna Fiora, Laura Fiorio, Berit Fischer, Fernando Fraguela Fosado, Frency, Jorge Gómez, Ruth Gonzalez Renovato, Paz Guevara, Ezgi Hamzaçebi, Ibrahim Hannoon, Fabian Hesse, Rawand Hilles, Sophie Houdart, Lorena Juan, knowbotiq, Julia Lazarus, Maxime Le Calvé, Argelia Leodegario Calderón, Marianna Liosi, Henry Lyonga, Carina Madius, Nahed Mansour, melke, Carolina Mendonça, Paula Montecinos Oliva, Tobias Morawski, mordo, Rimi Morrison, Vassilis Noula, Nikolay Oleynikov, Isabel Paehr, Giorgos Papadatos, Sergio Pereira, Practices of Attunement, Helen Pritchard, Raumlabor Berlin, Jörn Röder, Marco A. Rodríguez, Özlem Sarıyıldız, Savvy Contemporary (Lynhan Balatbat-Helbock, Kelly Krugman), Shohreh Shakuri, Saleh Abu Shamala, David Shongo, Eric Snodgrass, Walter Solon, Tactical Technology Collective, Telekommunisten, Consuelo Terra, Constantina Theodorou, Linda-Philomène Tsoungui, Mila Turajlić, Jacob Veidt, Benoit Verjat, Wangūi wa Kamonji, Mitra Wakil, Małgorzata Wosińska,

Ekua Yankah, Karim Yassin Goessinger, Catherine Sarah Young, Mukhtara Yusuf, Zakole, Mathias Zausinger.

Thanks also to all the lecturers of *The New Alphabet School* editions: Rana Al-Batrawi, Liliana Angulo, Emily Apter, Tania Bruguera, Munir Fasheh, Silvia Federici, Avery Gordon, Jack Halberstam, Ranjit Hoskoté, Nikita Kadan, Meena Kandasamy, Anja Kovacs, Elke Krasny, Peter Linebaugh, Lydia Liu, Natalie Loveless, Juan Rodrigo Machado Mosquera, Lionel Manga, Fred Moten & Stefano Harney, Chantal Mouffe, Nelly Y. Pinkrah, Elizabeth Povinelli, Joanna Rajkowska, Helena Reckitt, Irit Rogoff, ruangrupa, Shareef Sarhan, Saskia Sassen, Richard Sennett, Adania Shibli, Felix Stalder, and Sigrid Weigel.

We thank all the artists who contributed to the various editions: Ghayath Almadhoun, Malu Blume, Johanna Bruckner, Cheikha, Amaury Pacheco del Monte, Mour Fall, Fundación Cultural Pilón, Liv Furga and Tomasz Szczepanek, Ivonne González, Mario Henao, Christian Howard Hooker, Ibaaku, Muhammed Lamin Jadama, AM Kanngieser, LoMaasBello, Jorge Loureiro, Macú, Daba Makourejah, Daniela Maldonado (Red Comunitaria Trans), Lene Markusen, Maternal Fantasies, Johan Mijail, Cléophée Moser, Yos Piña Narvaez, Majdal Nateel, Ania Nowak, Ariel Palacios, Pallavi Paul & Hajra Haider Karrar, Plu Con Pla, Polyphrenic Creatures, Tabita Rezaire, Alioune Samb, Abdullah Sow, Nathalie Vairac, Nicoline van Harskamp, Muhammad Zohud.

We thank all blog authors: Amani Aburahma, Laeïla Adjovi, Vinit Agarwal, Ghayath Almadhoun, Mohammed Alzaqzouq, Emily Apter, Yahya Ashour, Athena Athanasiou, Ariella Aïsha Azoulay, Karla Barroso, Kamran Behrouz, Claudia Bernardi, Malu Blume, Edna Bonhomme, Daniela Brasil, Loren Britton, Johanna Bruckner, Boris Buden, Manuel Callahan, Liliana Angulo Cortés, Marinho de Pina, Isabel de Sena, Carla Dietmair, Teresa Dillon, Paolo Do, Kike España, Munir Fasheh, Berit Fischer, João Florêncio, Tyna Fritschy, Andrea Ghelfi, Christos Giovanopoulos, Celia González, Matthew Goulish, Valeria Graziano, Atreyee Gupta, Ibrahim Hannoon, Stefano Harney and Fred Moten, Karin Harrasser, Johanna Hedva, Rasha Hilwi, Ibaaku, Saodat Ismailova, Shafali Jain, Alexandros Kioupkiolis, Gal Kirn, Agata Kowalewska, Elke Krasny, Sophie Krier, Olga Lafazani, Maxime Le Calvé, Diana Lelonek, Lydia H. Liu, Isabell Lorey, Juan Rodrigo Machado Mosquera, Lionel Manga, Marcell Mars, Maternal Fantasies, Shannon Mattern, Tomislav Medak, Isabel Mehl, Andrea S.

Micu, Romi Morrison, Gerardo Mosquera, Mwape J. Mumbi, Pallavi Paul, Šoela Petrič, Polyphrenic Creatures, Elizabeth A. Povinelli, Nina Power, Helen Pritchard, Gereon Rahnfeld, Pantxo Ramas, Gerald Raunig, Patricia Reed, Frida Sandström, Julia Schlüter, Melanie Sehgal, Saleh K. Abu Shamala, Adania Shibli, Eric Snodgrass, Felix Stalder, Simone Stimm, Yayra Sumah, Anaïs Tondeur, Joan Tronto, Sónia Vaz Borges, Rolando Vázquet, Kasia Wolinska, Catherine Sarah Young, Mukhtara Yusuf, Zakole.

We thank all our partner institutions and collaborating venues, Goethe-Institut / Max Mueller Bhavan New Delhi, The Common Room, The Story Of, M.1 / Arthur Boskamp-Stiftung, RAW Material Company, École des Sables, Bibliothèque Terme Sud, Goethe-Institut Senegal, EIGHT – critical institute for arts and politics, Goethe-Institut Athens, the Porto Summer School on Art & Cinema, 28 magazine gallery, Goethe-Institut Ramallah, INSTAR – Instituto de Artivismo Hannah Arendt, Biennale Warszawa, Goethe-Institut Warsaw, and the Faculty of Philosophy at the University of Warsaw.

For their care, thanks are extended to all those at HKW who worked so hard to realize the project: Anna Etteldorf, Verena Stahl, Anja Dunkel, Adam Luczak, Clemens Huebner, Sima Reinisch, Simon Franzkowiak, Matthias Hartenberger, Anastasios Papiomytoglou, Claudia Peters, and Nadja Hermann.

Special thanks go to all colleagues and comrades who acted as advisors and interlocutors, notably: Annette Bhagwati, Stefan Aue, Adania Shibli, Nishant Shah, Srinivas Kodali, and Shuddhabrata Sengupta.

A very important thank you to Bernd Scherer, for his trust and support.

Olga Schubert, Gigi Argyropoulou, Mahmoud Al-Shaer, and Rahul Gudipudi

Common Research

"Common" is a slippery term—its connotations, both laudatory and shameful, go in every which direction: it implies sharing and mutuality and freedom of access at one end (as in elaborations of the Commons) and equally implies socially snobbish insinuations of inferiority and exclusion that serve as gatekeepers, at the other. And somewhere between these two poles there is also the notion that "common" is frequent and omnipresent, easily located, not distinguished by either origins or characteristics but by its sheer presence, like certain birds or plants that are barely noticed in their humble ubiquity.

"Common Research" for me is a recognition of an appetite to know what is pervasive and yet critically situated. More importantly, it is a drive to research what we can locate in those places and guises that we would not have thought to look for in research-based knowledge. Research not dignified by institutional authorities or long lines of distinguished inherited knowledges, but by its insistent presence as a texture, atmosphere, or a manifestation of something demanding attention and investigation. It is an important designation in moments such as ours—of pandemic, economic recession, overall volatility, and war, in addition to the ongoing crisis of neoliberal capitalism—that we look away from those old and clear trajectories of research and rethink what the drive to know is and how it intersects with the heterotopian crisis landscapes in which we are situated.

"Common Research" is then a term aimed at the democratization of the notion of research at a moment when research is being recognized as part of the fabric of daily life as well as of watershed moments, existential crises, and enduring momentous instabilities.[1] It intimates not simply greater accesses but also greater recognition for who is considered a knowledge producer and what is considered knowledge. I am drawn to the term "Common Research" as for some

1 *The charter of the European Form for Advanced Practices* (advancedpractices.net/charter) states that one of the ambitions of Advanced Practices is: "Advanced Practices insist on a democratization of knowledge, with more persons having access to it and being recognized as knowledge producers."

time now I have been trying to think around two issues: first, how to characterize work that is not designated as part of the research structures of higher education as significant research, by which I mean research that can be circulated, passed on, elaborated upon, and recognized as "epistemic invention"; and second, how to think about research methodology emanating from unstable conditions as agitated forms of knowing. Here, the question is one of how to develop research methods that reflect instability, precarity, and insecurity rather than translate these conditions into stable and unwavering logics that deny the affective dimensions of what is being looked at.

In this I have often come back to Gregory Bateson's idea of a malfunctioning relation to knowledge.[2] What does this malfunctioning relation to knowledge consist of? How does it get performed? Does it require legitimation and, if so, from whom or what? And most importantly, is it indexical of the conditions that have necessitated it in the first place and is it able to produce affective registers that convey these in the form of research, that is, relational knowledge that is tested, elaborated upon, and passed on. There are playful intimations about this proposition for malfunctioning knowledge, as there always are with Bateson, introducing a sly wedge between research platform and its utilization and instrumentalization as applied knowledge in business, creative industries, data collation, criminal investigation, or in the smooth build-up of a classroom syllabus. But there is also a hopeful opening—for me at least it instantiates a disruption of methods and protocols on the one hand and of the applied instrumentalization of research on the other. The appeal is that our work will be able to perform its glitches, misunderstandings, misrepresentations, good and bad intentions, and the incomprehensions in which it is embedded. That this performance is not simply a set of individual crisis, but the genesis of actual methodologies. Thus, Liberty Russell's manifesto, *Glitch Feminism* argues that the cyber world is indelibly embedded within the physical world and that its glitches are not technical malfunctions but "structures of feeling" which span both worlds

2 See Gregory Bateson, *Steps to an Ecology of Mind: Collected Essays in Anthropology, Psychiatry, Evolution, and Epistemology*. Northdale, NJ: Jason Aronson Inc, 1972/1987.

and dictate scores for functioning within them.[3] Equally, there is a dismissal of the authority of knowledge, for what can authority malfunction perform? It is precarity itself, hopefully, eternally open to disappointment.

For several decades now, we in curatorial studies have been speaking about the importance of "unlearning" and "unknowing" as a way to shed the yoke of unconscious biases and the long histories of colonialism and imperialism. But the promise of Bateson's idea is that this is not simply a necessary step toward getting us to a better place in which we can know in a less biased way—it's a permanent affective state that reshapes "knowing" rather than what we know. Bateson's desire for a "malfunctioning knowledge" is not so much a desire for knowledge that doesn't work, but rather a desire for knowledge that cannot be absorbed into smooth function within dominant logic. Bateson was a master of what I would call "epistemic improbability"— entertaining improbable occurrences not in order to provide them with a smooth interpretation, but to turn them against an intuitive logic, to interrogate what one might be seeing and the narrative one might be imposing on it. And as such, Bateson pursues a polyphonic form of research in which languages are mismatched, misunderstood, and don't stand a chance of translation.

I have a great number of artistic interlocuters in pursuing this line of thought—Walid Raad and Theaster Gates, Rabih Mroué and Bouchra Khalili, Isaac Julien and Sonia Boyce, Naeem Mohaiemen and Akram Zaatari, John Akomfrah and Trinh T. Minh-ha, and the curatorial legacy of Okwui Enwezor which redefined what the horizons of the exhibition could be, as well as that of David A. Bailey and Vali Mahlouji both of whom have literally conjured up archives. This work has produced a shift in the demands put on viewers and the understanding of exposition and public manifestation it puts forward. My list of interlocuters is long and includes many others, but I don't want to exemplify or illustrate these thoughts through their work as the relation here is reversed, their work has spurred these thoughts, moved

3 Liberty Russell, *Glitch Feminism: A Manifesto*. London: Verso, 2019. See review by Jesse Damiani, "On Embodying The Ecstatic And Catastrophic Error Of Glitch Feminism: Book Review," *Forbes* (October 15, 2020), https://www.forbes.com/sites/jessedamiani/2020/10/15/on-embodying-the-ecstatic-and-catastrophic-error-of-glitch-feminism-book-review/, accessed May 19, 2022.

goalposts, and set up challenges. It makes little sense then to document it as a form of material confirmation that this shift I am speaking of really is taking place. It is part of a much larger transformation in the ability of creative practices to summon up new realities, that both reference what we know and invent other scenarios for knowledge.

The context framing this proposition for "Common Research" is the sea change affected by contemporary practice-driven research emanating from creative practices and impacting the forms, protocols, and evaluation of research across the arts, humanities, and social sciences. This shift is not simply an expansion of the subjects of research, but is about new research drives propelled just as much by lived conditions as by inherited formal knowledges. Our conditions are impacted daily by precarity, scarcity, sustainability, legal uncertainty, security, and financialization—these necessarily shape subjects, methodologies, and audiences of research.

The humanities, arts, and social sciences are currently situated on the cusp of a paradigm shift in the ways that knowledge is conceptualized, articulated, assembled, and disseminated. Following from the traditional models of archival, data-driven, and analytical research, a series of material and affective modes have entered the arena introducing questions of the *sonic*, the *performative*, the *embodied*, the *spatialized*, the *narrated*, the *displayed*, the *fictionalized*, the *digitalized*, the *participatory*, and the *organizational* among many others. Equally, research questions are emanating from a set of conditions, such as the environment or the economy, migration and globalization, or the fluidity of gendered identities. My aim is not simply to focus on and describe such conditions, but to recognize how they shape an entry point and a methodology. The arts have been a defining force within this paradigm shift, allowing for a renewed notion of "research" to emerge as a practice in and of itself rather than as a preparatory activity taking place in advance of a body of work.

Within scholarship, the question of affective as opposed to purely cognitive knowledge formations has become central, while in practice-based work, the invention of new temporalities, new knowledge languages, and an emphasis on "doing" as an investigative process have shifted both the protocols of learning and researching as well as of delivering outcomes. Collaboration, conversation, gathering, exchange, and the occupation of certain sites have emerged as modes of research in and of themselves, while museums, galleries, NGOs, and

protest movements have all also become sites of knowledge production requiring these be understood as research findings, independent of whatever displays they might be connected to. The transdisciplinary breadth of this shift to practice-based research has also impacted anthropology, sociology, cultural studies, architecture and spatial studies, and the creative industries among many others. One of the things that compels me about all the different activity I see around me and take part in is the range of knowledges at work: high theoretical ones, philosophical, economical, logistical, and organizational ones, technical ones, scientific ones, pedagogical and communal ones—all married to exceptional levels of imaginative invention and creative vision. The migration of terms such as "fieldwork" from anthropology to both artistic and performative practices, or the "curatorial" as an instance of assembling, or "performativity" as a modality of manifestation, point to shared ground around practice. A good example of this could be the way in which engagements with crop agriculture can be conceptualized as fields of convergence between climactic conditions and food resource capabilities while simultaneously dealing with regional and community histories whose narration capacities and relation to species shape the field as much as the supply calculations.

"Research"

Equally, the concept of "research" is being stretched through many practices and is no longer the remit of research institutions or environments. As such, an entry point into a creative investigation can be a known event, situation, or set of conditions. The knowledges that come together in the instance of "research" may emanate from several unrelated fields and the process can result in often new relations between these knowledges. The mode of recounting or making manifest such an inquiry can be its fictionalization or its casting into an unconventional dramatic narrative told through an invented voice. Forms of personification, animate and inanimate, allow sidestepping the conventional narratives of military conflict, environmental crisis, identity exhaustion, institutional collapse, or technological saturation, in order to find new points of entry into problematics weighed down by predictable representations. Previously, artistic practices were only seen as paradigm shifters in terms of the radical aesthetics

they proposed. Currently, we understand that they provide new modes of engaging with the world on their own terms. This is characterized by Jacques Rancière's notion of the artwork as a "distribution of the sensible,"[4] that is, through organization of the way in which reality is being made accessible to the senses. Such an extensive set of shifts in both creative methods and expectations from participators as conceptual stakeholders, necessitates a far more complex set of terms to make it legible across the institutional and cultural landscape.

Throughout the last decade, we have seen an increasing interest in artistic and practice-based research formats. Foundational to this development is the hypothesis that sociocultural practices contribute to the production of knowledge, and that knowledge stemming from these sources should be made accessible to (and enter into dialogue with) more traditional forms of academic or scientific knowledge.

In order for us to be able to work with and be guided by such an altered understanding of research, we need to recognize the energetic vectors traversing it and constituting the work in the field. We need a new language for new modes of practice research because we need to enact it, not just describe it. We need this new language to not just be descriptive but also declarative, to enfold within it the taking up of stands, of riding the crest of intentions, of marking the unthinkable and the unarchivable. To pursue work in this area I have become wedded to the concept of "Advanced Practices"—not in the sense of more excellent practices, but practices that open up and propel forward. This becomes necessary as our neoliberalized institutions of education and research have become instruments of logistical management and our endlessly monitored and evaluated work has been hijacked by vacant notions of "value," as in "impactful" within commodified markets of social change quantitively assessed.

We now need these updated terms for understanding the value of new research sensibilities so that every research grant, book proposal, or course outline can be interrogated as to whether it achieves these non-logistical ambitions, instead of fulfilling vague notions of societal good: does it invent new relations between knowledges? Does

4 Jacques Rancière, *The Politics of Aesthetics: The Distribution of the Sensible*, trans. and ed. Gabriel Rockhill. New York: Continuum, 2006.

it shift paradigms? Does it exceed expectations? Not even with the best intentions in the world could those vague notions of societal good be fulfilled, because knowledge cannot be inventive and instrumentalized in the same breath. Here, Brian Massumi offers some guidance to address these questions. He argues that the regime of "evaluation" (which is a regime of judgement) will always adhere to a set of normative "worths" and, secondly, that "To uncouple value from quantification in a way that affirms an ecology of qualitatively different powers means engaging head-on with the economic logic of the market. Value is too valuable to be left to capital."[5]

Vocabularies

So here are some of the terms that have proved necessary for shaping the terrain, which have so far been shaped by normative knowledges and market interests. Terms that help us to see how research is emerging in the present moment and how value might be attributed to it.

Permission—How artistic and creative practices have reshaped the understanding of "permission" for knowledge to both invent methods and protocols and to claim forms of legitimation. The understanding is that we are never "granted" permission but rather need to struggle for it, substituting legitimacy and authorization for forms of inevitability. Permission, thus, is the state of finding one's self compelled within a force field. Not externally authorized but compelled to make a move in relation to all the conditions one is aware of, which is very different from having the right position or doing the right thing. It is what Kathleen Stewart has called "atmospheric attunements":

> An atmosphere is not an inert context but a force field in which people find themselves. It is not an effect of other forces but a

5 Brian Massumi, *99 Theses on The Revaluation of Value: A Postcapitalist Manifesto*, https://manifold.umn.edu/read/99-theses-on-the-revaluation-of-value/section/7a105a04-8cb5-4b6f-8818-2ca4cd070862, accessed May 20, 2022. Massumi argues that "value" has been hijacked by neoliberal modes of quantitative and computational evaluation and that we need to counter these with substantive notions of "value" that address what is significant for who and under what circumstances.

lived affect. A capacity to affect and to be affected that pushes a present into a composition, an expressivity, the sense of potentiality and event. It is an attunement of the senses, of labors, and imaginaries to potential ways of living in or living through things. A living through that shows up in the generative precarity of ordinary sensibilities of not knowing what compels.[6]

The research that is its outcome is then multipositional, multivalent, and immersive. When a broad and eclectic range of knowledges converges within an inventive investigation, forms and languages are developed to redress the relations between those knowledges. Equally, atmospheres and states of mind that aid in countering dominant logics are invoked. "Radical Black Study" has been a driving force here, as has the emergence of the term "choreographic," to link social knowledge to embodiment. Kathleen Stewart again: "In the expressivity of something coming into existence, bodies labor to literally fall into step with the pacing, the habits, the lines of attachment, the responsibilities shouldered, the sentience, of a worlding."[7]

Fictioning and Docu-dramatizing—Recasting a set of facts and realities through the invention of fictional contexts, imagined archives, and imagined narratives within them. Establishing an understanding of the gap between what we have access to and what we wish for—wish, not as academically sanctioned, verified, and provable knowledge, but as "common knowledge" that elicits different forms of belief, sustained by enactment rather than discursive repetition. Performance art (Rabih Mroué, Adrian Heathfield), theoretical works of "fictioning" (David Burrows and Simon O'Sullivan), and science fiction and Afrofuturism's essential narrative forms have all been driving this strand of the investigation.

In his persuasive book, *Singularities,* André Lepecki attributes an important testimonial role to an audience who has been enthralled to believe and imaginatively invest through experience:

6 Kathleen Stewart, "Atmospheric Attunements," in *Environment and Planning D: Society and Space*, vol. 29, no. 3 (2011), pp. 445–53, here p. 452.
7 Ibid.

The audience then becomes itself, not at the moment it wit-
nesses the event, but when it gives to an other its testimony of
the event. The audience becomes one only as long as it opts to
become an actor-storyteller in the future (near or far). This op-
tion is the initiative that defines a political act. In this sense,
the audience also fulfills its true aesthetic function. The funda-
mentally affective-political task of storytelling, its relation to
both historicity and futurity, is crucial in the age of selfies.[8]

We enter the narrative, we establish a connection with it, which has to
do with how we want to know, and this in turn becomes an important
"value" of how to know.

Epistemic Invention—Practices that propagate new, propositional realities,
not epistemologically but through their collective and multidimen-
sional enactment. The invention is the possibility of not reporting on
existing conditions but propagating new realities. To my mind, this is
not identical with "fictioning" as it deals with a stretching of concepts
to a point that they can neither any longer contain the arena of the ac-
tivity nor the horizon of how far they might reach. Exhibition works
such as *Making Things Public* by Bruno Latour and *The Short Century*
by Okwui Enwezor have posited arenas as sites of "worldmaking,"
both exceeding the scope of what is shown in the exhibition and of
grasping the terrain of the world with which it is affiliated.[9] In Jean-
Luc Nancy's oppositional stance to globalization, worldmaking is "a
set of relations between people, places, conditions, heritages and
hopes driven by the need to both *envisage* and *inhabit*."[10] For Nancy,
worldmaking, therefore, is a *process in expansion* in reference to the

8 Andre Lepecki, *Singularities: Dance in the Age of Performance*. London:
 Routledge, 2016, p. 177.
9 Principal curators Bruno Latour and Peter Weibel, *Making Things Public:
 Atmospheres of Democracy*, ZKM, Karlsruhe, March 19–August 7, 2005.
 Okwui Enwezor, Survey Exhibition: *The Short Century: Independence and
 Liberation Movements in Africa 1945–1994*, MCA Chicago, IL, touring
 February 15, 2001–May 5, 2002.
10 Jean-Luc Nancy, *The Creation of the World or Globalisation*, trans. with
 Introduction by François Raffoul and David Pettigrew. Minneapolis, MN:
 Minnesoate University Press, 2002. Quotes amalgamated from the Preface.

world of humans, of culture, and of nations in a differentiated set, as opposed to a process of globalization which operates as a world system based on flows and circulation within their own logic of profit and efficiency. It is seductive to think of cultural projects as forms of "worldmaking" so that we can begin to take such projects to distant places and set up links with other formally unrelated knowledges.

Infrastructures of Feeling—Thinking of "infrastructure" as a condition rather than as a set of regulated resources, invoking Raymond Williams' famous dictum of "structures of feeling." It is an opportunity to expand Bateson's "malfunction" within practice.

Largely held captive by planning discourses, infrastructure is seen as the ultimate mode of technical, organizational support delivery. Sewage, energy, capital flow, traffic, transportation, food, information technology, and transglobal services are seemingly the building blocks of contemporary geodemographic organization. Given that infrastructures are the building blocks of capitalism's modus operandi, is there a potential to think about this model of efficient delivery critically? To introduce both subjectivity and incoherence into its workings?

Recognizing the levels of logistical management in which we exist, it is no wonder that we have become "infrastructural beings." Our conditions today are infrastructural, providing the hidden rules for structuring the spaces and actions all around us. Creative practices have the capacity to locate and constitute new understandings of infrastructure. Immaterial and affective infrastructures that are propelled and animated by the "ghost in the machine" rather than by satisfying the need for efficient delivery of goods, capital, energy, transport, and waste.[11] Thus, to the vocabulary of "Common Research,"

11 The freethought-collective has been dealing with trying to understand and stretch working notions of "Infrastructure" and take these to less expected places. See freethought-collective.net, where there is extensive documentation of the various projects that made up the freethought-collectives' "Infrastructure" project at the Bergen Assembly 2016. Currently this is being developed to its next phase as "Spectral Infrastructures" hosted by the discursive space BAK, basis voor actuele kunst, Utrecht, https://www.bakonline.org/long-term-project/spectral-infrastructure/#:~:text=%E2%80%9CSpectral%20Infrastructure%E2%80%9D%20is%20a%20long,%2C%20research%2C%20and%20public%20programs, both sites accessed May 22, 2022.

I would like to add the notion of "Infrastructures of Feeling," in order to exit the burden of having to set up a historical or material context for the things we are examining, experiencing, and setting up. Instead of contextualizing, we can envisage ourselves as halting our capture by the mechanisms of delivery, supply, and resourcing, which do not operate as a context, therefore, are not historically fixed, and thus can be changed, as we intervene in the horizon of possibility.

––––––––

This very brief vocabulary that might allow working with practice-based research as an enactment and expansion, as "Common Research," is hardly definitive. It calls forth a surge of conjured-up vocabularies that are ephemeral and unstable. We don't really need another canon— a canon of practice research—this time around, though we do need to know the practices. However, we do need a means by which we can stretch these practices to their full potential, charting realms of encouragement, granting ourselves permission, freeing ourselves from dependence, stalking the boundary lines that divide our realms of knowledge, until these are worn to dust.

In her moving and inspiring work *In the Wake: On Blackness and Being*, about the afterlives of slavery, genocide, and elision, Christina Sharpe says "I am interested in how we imagine ways of knowing that past, in excess of the fictions of the archive, but not only that. I am interested, too, in the ways we recognize the many manifestations of that fiction and that excess, that past, not yet past, in the present."[12] Located as we are within a set of current internal and external crises ranging from the necessity to decolonize and to withstand health, economic, and political violence, I can locate in the research practices ways to both know and live out our present.

For a long time, I thought that the only potent weapon I had to counter the ever-increasing stranglehold of neoliberal technocracy was *seriousness*. To be serious, to go into things in depth, to resist instant calculation of benefit, to elaborate arguments that don't rush to the bottom line, to resist the fake ethics of "social good," to risk not

12 Christina Sharpe, *In the Wake: On Blackness and Being*. Durham, NC: Duke University Press, 2016, p. 17.

being instantly legible, to take up slightly obscure preoccupations—all of these seemed to me to enact a form of resistance. Now I have "research" as well, seeing that in its very impulses it is a denial of hegemonic knowledge as well as regulation of capital accumulation.

For sure, we need to be brave and to be hardy, we need to vehemently resist the logics foisted upon us, but we also don't need to just get past these crises and weather the storm—we need to make the storms count. And count for all.

Collective Autotheory: Methodologies for Kindred Knowledge Practices

"The personal is theoretical."
Sara Ahmed, *Living a Feminist Life*, 2017

It was during a conversation with Jane Rendell that I heard the term "autotheory" for the first time and it immediately clicked with me. That particular conversation was centered around design pedagogy, how discipline and learning are entangled with norms of domination and hierarchy, and what teachers and students can do to expose and engage with these hidden structures. Jane generously reflected on her own role as an architecture professor looking to teach beyond the borders of what the university might understand architecture to be, and how she actively encourages her students to tell stories that differ from the norms we feel oppressed by. She described autotheory as a space where the natural relationship of self-reflection and social critique is accentuated, in a "spatially or specifically situated version of self-writing." In this conversation, Jane links this term to works such as Michel Foucault's "self-writing" and Donna Haraway's "Situated Knowledge," as well as her own "Site-Writing." Jane is a feminist spatial scholar whose theory and terminology have helped me to define my own work as curating critical spatial practice. This has helped to give scope to my own field of practice, enabling me to see clearly the places where I choose to respect boundaries and where I aim to jump over disciplinary or gender hurdles.

After this conversation with Jane, I began to research autotheory and found out that it holds immense political potential for renegotiating knowledge production in cultural and academic as well as in popular settings. Being in dialogue, or engaging with a group, one inevitably has to reckon with the needs and desires expressed by others in direct and indirect ways.

Crucially, autotheory charted the way to introducing a personal perspective to my work, to explain and negotiate the essential gap between myself and others in practice. It is this tension between individual and collective desires that I will focus on in this text and what I attempt to address with collective autotheory as a methodology.

Beyond a very brief subjective reading of the emergent terminology around autotheory, I want to describe how two projects of mine—*Silent Conversation* and *Letters to Joan*—both in relation to *The*

New Alphabet School, constituted experiments in practicing collective autotheory. In this way, I want to propose collective autotheory as an approach to making shifts in kinship, or making kinshift.

Autotheory

The term autotheory is commonly attributed to Stacy Young's work on writing and publishing practices within the North American women's movement and her 1997 book, *Changing the Wor(l)d: Discourse, Politics and the Feminist Movement*. In Chapter 2, "The Autotheoretical Texts," Young describes the life-writing of Black feminists within the women's movement as political life-writing practice—that is, it departs from academic norms to include private accounts and meshes them together with critical theory.

> The power of the autotheoretical texts lies, in part, in their insistence on situatedness and embodiedness. The writings' autobiographical nature clarifies the origins of their insights, and thus underscores the contingency of their claims (indeed, of claims about social reality in general). It also works as an invitation to the reader to examine her own multiple positions—in relation to the author/narrator (the relationship is not always one of identification) and, by extension, to other readers and authors; and in relation to various aspects of the social structure. These texts combine autobiography with theoretical reflection and with the authors' insistence on situating themselves within histories of oppression and resistance. The effect is that the texts undermine the traditional auto-biographical impulse to depict a life as unique and individual. Instead, they present the lives they chronicle as deeply enmeshed in other lives, and in history, in power relations that operate on multiple levels simultaneously. Moreover, in their shifting back and forth between the narrators/authors as individuals and the larger social forces in which they are caught—and which they seek to transform—the texts *perform* the politics for which they argue.[1]

1 Stacy Young, "The Autotheoretical Texts," in Young, *Changing the Wor(l)d: Discourse, Politics and the Feminist Movement*. Abingdon: Routledge, 1997, p. 69.

Thus, while reemerging in current art discourses now, autotheory in fact originates with observing Black feminist writing practices, which at their core were a critique of the women's movement's universalist undertones. Arguably, the autotheoretical texts go a long way to challenging the category "woman" altogether—in identity, in origin, and in theory. The autotheoretical texts insist on diversity inside of social categories such as gender, and not only between them, in order to be able to situate persons more precisely and thus embody resistance to the oppressive universal logics which apply strict categorization in order to assert power.

Among many other works since Young's writing about autotheoretical texts, two quite recently published authors have used the term to describe their critical self-writing approach: Paul B. Preciado's *Testo Junkie* and Maggie Nelson's *The Argonauts*. Both books offer accounts of gender transformation: Nelson depicts the transition of her partner Harry Dodge while she herself is pregnant and grapples with oncoming motherhood, whereas Preciado is describing his own transition through a theoretical exploration of the technopharma-political condition or as he describes it in the very opening sentences of the introduction, "This is a somato-political fiction, a theory of the self, or self-theory."[2]

Autotheory might be understood as a practice that declares its intention to transform discourse from within. In this way, transformation is central to the autotheory form, suggesting that it is the site of personal transformation as prefiguration of a social transformation. Autotheory is a critical form of free indirect speech—whereby the author's viewpoint intermingles with the seeming objective stance of a theoretical position in order to change understanding of that objectivity from within. The autotheoretical dialogue between objectivity and subjectivity is used as a tool for transformation, resistance, and liberation.

Collective Autotheory

It is precisely because autotheory insists on acknowledging the ways in which context and situation shape the voice of the author, exactly

2 Paul B. Preciado, "Introduction," in Preciado, *Testo Junkie: Sex, Drugs, and Biopolitics the Pharmacopornographic Era*, trans. Bruce Benderson. New York: Feminist Press, 2013, p. x. See also Maggie Nelson, *The Argonauts*. London: Melville House, 2015.

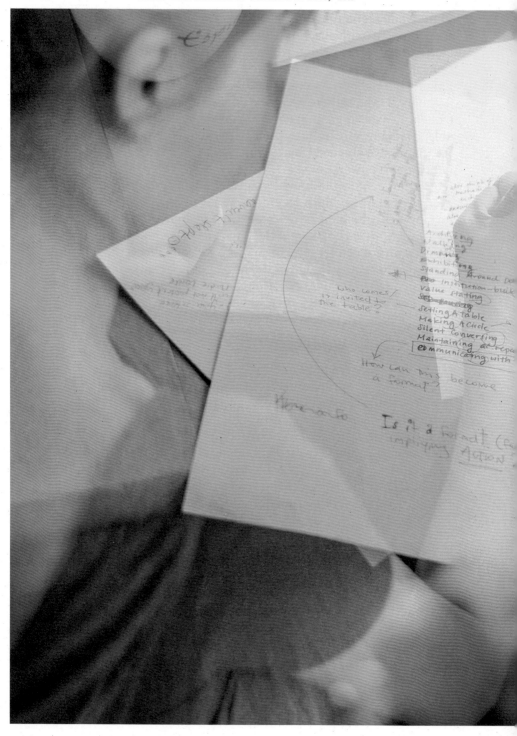

because it provides the reader with access to embodied experiences, one to which they can relate in first person, that I will claim that auto-theory is inherently also about collectivity, and about journeys traveled together.

Readers of autotheoretical texts will not only gain access to narratives, ideas, and theories, but they will also gain insights into methodology, as these texts suggest a method of moving back and forth between private life and the social structures in which those lives reside, assessing the impact they have on each other. Recognizing the writer in her body, site, genealogy, culture, and time does three things that, when combined, could be observed as a methodological protocol in that they contextualize, embody, resist.

Autotheoretical texts call on us to do otherwise in social relationships by employing the tools that Young studied—reading, writing, and publishing—and which remain central to the production and dissemination of knowledge. I wish to find more tools with which we might collectively create stories—tools to embody the politics that might collectivity promote collectivity. For example, how can we engage in collective decision-making where the dynamics of conversation do not oppress some voices, but which rather amplify all voices so that everyone is heard and trusted for their viewpoint? How can we form collective narratives for coherently describing a place or a group? How can plural narratives coexist, contaminate, and co-constitute one story?

These questions express a wish to negotiate the space between individual and collective ways of knowing and to find kinship that holds them together, accepting their validity as incommensurable. This constant reconsideration of changing needs, desires, and conditions between diverse individuals requires tools of conversation and exchange, as well as structures for collective self-determination. The relational nature of autotheory communicates through and across identity in order to tell stories that shape us all through symbiosis with others. As gleaned by Arianne Zwartjes: "In many ways, autotheory engenders collectivist, rather than individualist, worldviews; it uses theory to recognise the power of shared connection, shared experience, in fragmented and isolated time."[3]

3 Arianne Zwartjes, "Under the Skin: An Exploration of Autotheory," *Assay: A Journal of Nonfiction Studies*, vol. 6, no. 1 (2022), https://www.assayjournal.com/arianne-zwartjes8203-under-the-skin-an-exploration-of-autotheory-61.html, accessed May 18, 2022.

I wish to describe how I practice collective autotheory through two projects I recently conceptualized. Two projects which attempt to write theory collectively in different settings, through conversational formats of writing, emphasizing the relationship between different writers, in order to compose the whole. Through these practices, I wish to ask: can autotheory become a collective tool for aligning group identity, politics, and action?

Silent Conversation

My engagement with *The New Alphabet School* came via an invitation from Boris Buden and Olga Schubert. They had both attended a workshop in 2018 at the Floating University Berlin as part of the collective lexicon writing process I had been designing for the site. I held *Silent Conversation* workshops for the lexicon process, where terms relating to the site of the Floating University Berlin were being silently co-authored in written form. This was an attempt to describe collectively ways of thinking and ways of making for a specific practice on a specific site. In its disrupted, hyper-local, collective form, *Silent Conversation* gives agency both to the site and to the process as producers of knowledge. This lexical technique neither produces encyclopedic definitions nor furthers synthesis—the definitions remain as they were sketched initially on paper, frozen in time, in a process that is a game, a collage, and a meditation. In this way, the moment of thinking and writing together becomes the focus and the image of the term. I consider the *Silent Conversation* format to be collective autotheory, in that it captures a moment of cross-pollination between people, a site, and a situation.

The design collective Brave New Alps used *Silent Conversation* in a community economy workshop. Here, they describe the process they use:

> We divide into groups with an equal number of people, keeping in mind that the ideal group size is 10. The groups sit in a circle, around a table or on the ground. Each person receives one A4 sheet and a pen. To start with, every person writes a sentence, slogan, hashtag or drawing on their sheet, which they use in their own context when talking about creating a different way of doing economy or a different way of operating in their con-

text. After 90 seconds, each person passes their sheet on to the person sitting next to them in clockwise order. We then continue with 90-second time slots to respond to what we find on the sheet that has been handed to us. We continue this way until everyone has their original sheet back. The facilitator times the rounds—90 seconds each.[4]

Different workshop facilitators in different settings might change the time given to each round. I normally give more time to the first round, where people propose an idea or a term to begin with, than to the commenting rounds. But the method is highly flexible and can be adapted according to needs and the nuances of the specific group taking part.

The terms and definitions in a *Silent Conversation* document a language of practice as well as a physical process of reflection. As the terms and comments are being written or sketched on to each page, a network of thoughts is being collectively formulated. When you look at a page, you can see the different relationships emerge between the initial writing and the comments in a way that challenges the knowledge hierarchy. In some pages, the first text written stands out clearly, in the middle or at the top, while comments, highlights, and sketches may appear around it. In other pages, it can be difficult to make out the original text from the comments that followed. On each page, the process of feedback, reflection, and conversation is made visual, capturing a raw, unfinished, imperfect process of communication. At the heart of the *Silent Conversation* is a methodology that does not so much *produce* as *frame* a process—it may coin new terms while never truly finalizing their definitions. In this way, many parallel discussions take place in the silent group. All voices get heard on the page, playing with the notions of authorship, the linearity of language, hierarchy of knowledge, and conversational dynamics.

In 2019, during the initial week of *The New Alphabet* project, as part of the "(Un)-Learning Place" series of events, I ran a workshop

4 Bianca Elzenbaumer and Fabio Franz/Brave New Alps, "Community Economies, a practice exchange: 7-8-9 June 2019, Vallagarina, Italy," *Snapshot Journal*, no. 1 (July 2020), p. 36, https://www.academia.edu/69095769/Community_Economies_a_practice_exchange_7_8_9_June_2019_Vallagarina_Italy, accessed June 9, 2022.

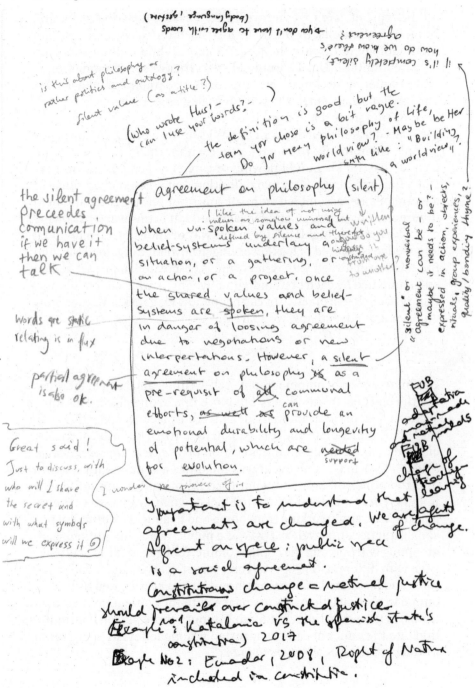

(upside-down at top:)
(body language , gesture)
4 you don't have to agree with words
agreement ?
it it's completely silent,
how do we know there's
agreement ?

is this about philosophy or
rather politics and ontology ?

silent value (as a title ?)

(who wrote this ! —
can I use your words ?—)

the definition is good, but the
term you chose is a bit vague.
Do you mean philosophy of life,
world view ? — Maybe better
sth like : "Building
a worldview"

agreement on philosophy (silent)

the silent agreement
preceedes
communication
if we have it
then we can
talk

I like the idea of not using
values as somehow universal but
When un-spoken values and
belief-systems underlay a
situation, or a gathering, or
an action, or a project. once
the shared values and belief-
systems are spoken, they are
in danger of loosing agreement
due to negotiations or new
interpertations. However, a silent
agreement on philosophy is as a
pre-requisit of all communal
efforts, as well as can provide an
emotional durability and longevity
of potential, which are needed
for evolution.

words are static
relating is in flux

partial agreement
is also ok.

Great said !
Just to discuss, with
who will I share
the secret and
with what symbols
will we express it ?

I wonder the process of it

"silent" or nonverbal
agreement can be - or
maybe it needs to be ? -
expressed in action, objects,
rituals, group experiences,
quality / bonding thyme ?

FUB

FLOB

Important is to understand that
agreements are changed. We are agents
of change.
Agreement on price : public price
is a social agreement.
Constitutional change = natural justice
should prevails over constructed justice.
Example No1 : Katalonia vs the Spanish state's
constitution) 2017
Example No2 : Ecuador, 2008, Right of Nature
included in constitution.

on the topic of care together with Elke Krasny, Rosario Talevi, and
Hannah Wallenfells, in which we also used the *Silent Conversation*
methodology to discuss the topic of care. While participants who
gathered for the "(Un)-Learning Place" series of events came from a
vast number of disciplines and practices, geographies and ages, for
our smaller group a majority self-identified as women.

As our group sat in a circle on the carpeted area in the foyer of
the Haus der Kulturen der Welt (HKW) silently working on the pages,
passing them to and from each other within the given time frame,
a collective thinking and knowing of care emerged out the process.
Not a finished, refined, textual definition, but an embodied sense of
a world of care, assembled from all contributions together and held
differently on each page and by each body. It is this way of knowing
care that I want to highlight, for in this way of knowing, no individual
knowledge is favored or less deserving. Knowledge is gained through
the relation of myself with others, and is co-created in this sense, but
still embodied by each of us individually. This is what collective auto-
theory could be—a practice of caring for how we gain knowledge, how
it is maintained, and how we share it.

Letters to Joan

The intersection of autobiography, self-writing, and critical theory is
not the end goal of autotheory but more its starting place. This inter-
section could act as a landmark or a meeting place for collective auto-
theory to build around and relate to. In June 2020, Rosario Talevi, Sas-
cia Bailer, and I co-curated the edition of *The New Alphabet School*
titled "#CARING." The event was meant as a general introduction
into the ethics of care and what it could mean for cultural practi-
tioners. Three months into the first lockdown in Germany, we (being
freelance curators working from home and dealing with different per-
sonal situations), as well as HKW as a public-facing institution, were
grappling with moving the content online, and questioning how to en-
gage with different concepts of care, remotely. We staged online lec-
tures and facilitated online workshops, but we also wanted to publish
online to allow participants to engage with the content on their own
terms, in their own time. In thinking about a more personal introduc-
tion into the ethics of care, I suggested writing letters to Joan Tronto,
a project that became *Letters to Joan*.

Joan Tronto is a North American scholar of Women's Studies and Political Science whose work on the ethics of care is central to the multidisciplinary search for an alternative paradigm to universal moral norms and their detrimental effects on society. Our wish was to engage Joan Tronto in order to recognize and map how various practices relate to the ethics of care, marking Joan's work a central node in this map.

Acting as a collective autotheory of care, the *Letters to Joan* also show a way to work collectively and individually at the same time. As a whole, the compilation allows the concept of care to be visited from diverse perspectives, it provides an overview of the spatial relations between all the aspects of care and is able to continually expand and evolve. It also stretches over time, to map how various generations might read and understand care ethics, and how they might be practiced in different contexts. We envisaged these letters and their responses making up a landscape of care—a relational map you can read from your own personal position. With this emerging map of care, it is clear to see how far the concept stretches—and how essential care is as an alternative paradigm.

Yayra Sumah, who follows in the footsteps of bell hooks and proclaims that "care is not love" as she reflects on the confusion of motherhood with care; Elke Krasny, who highlights how the coronavirus pandemic has hit women harder at home; João Florêncio points to the contested notion of "home" in times of self-isolation; Edna Bonhomme writes a litany for surviving Black death; Johanna Hedva points to the revolutionary potential of the bed-ridden body; Teresa Dillon turns our attention to more-than-human care concepts and the internet of life; Patricia Reed describes the co-dependency of care and knowledge, especially when thinking in planetary dimensions; and Johanna Bruckner follows particles as they escape from the earth's atmosphere and form new caring constellations in space.[5]

The discussion in *Letters to Joan* and *Silent Conversation* shows two different approaches to working with collective knowledge production. When taken together, the two projects provide a small-scale

5 See "Letters to Joan," in *New Alphabet School: #4 Caring* (June 20, 2020), https://newalphabetschool.hkw.de/wp-content/uploads/2020/06/ Letters-to-Joan-CARING-edited-by_BAILER-KARJEVSKY-TALEVI.pdf, accessed June 9, 2020.

comparative study to see how collective autotheory might look in practice. While the letters are individually authored by writers from various backgrounds and fields, they are still co-constituted in relation to Joan Tronto and to each other. The letter-writing format brings a more personal tone and encourages their authors to acknowledge the conversation with Joan Tronto as a departure point for their own contemplation. Unlike the *Silent Conversation* pages—where authorship is muddled, even abandoned—the authorship of the letters stays within the norm of the single voice, but one that is contextualized and relationalized within the compilation setting.

Authorship, Collectivity, and Non-Conclusion

When considering collective autotheory formats such as *Letters to Joan* or *Silent Conversation*, a discussion about authorship is essential. Having worked in partnerships and groups for two decades now, I can say with a degree of certainty that there is nothing more complicated and personal than the claims for authorship within collective production. Often resulting in toxic dynamics, the claim for authorship in collective situations usually occurs at the end or in the aftermath of a project.

The collective process is a Rashomon—that is, it is a situation where the ideas developed in practice are seen from as many perspectives and angles as the number of individuals who are engaged in it. No one person has a perfect memory of any situation. The truth is that no idea is pure and no project is comprehensively original. Contamination, inspiration, and rewriting is inevitable and untraceable. Still, when it comes to creative work, it is hard to let go of personal feelings—of ownership, authorship, or even affiliation for numerous reasons—feelings about maybe not being able to capitalize on the results of the work, or that there isn't enough recognition to go around, or that your part of the work isn't properly recognized, as well as the purely human emotions of envy or jealousy, or simply competition.

As a practitioner facing the question of authorship on a regular basis, I am always looking for ways to cope with these traps. Eventually, recognition is important for our contentment, while authorship translates into income. But we need to go beyond the mere representation of critique and insist on practicing collectivity in ways that do not deny recognition, and that do not create competition for income. A good place to start is by recognizing that these needs are real, and

then to share our feelings with each other in order to work through them together.

Having laid bare here the struggles of collective work, I want to quasi-conclude by stating that there is, in my eyes, no work more urgent today or more essential, than learning how to negotiate collectivity in all of its forms. Living through the sixth mass extinction, the fourth industrial revolution, a global pandemic, and the war-ridden collapse of financialized capitalism, we will only find shelter in collective efforts. And gladly, luckily, there are many traditions which we can still learn from to do exactly that. The idea that we know nothing about what will replace capitalism is wrong (and dangerous), as much as the notion that we don't have solutions to our pressing problems is designed to create despair. We do know. Learning from Indigenous communities and traditions is one important route we could take. Working towards indigenous sovereignty might be another. Alongside those, we might revisit many of the ideas that have long circulated within collective and collaborative practices of community organization, within social and environmental movements, and alternative forms of organization learned by feminist groups. All of these efforts offer collective road maps and recipes for a caring society. I strongly believe in collaboration, or otherwise in symbiosis. Collaboration always fitted me and still does. It fits me because I believe we are never self-contained. Because I see how present the world is within me. Much more than I am present in it.

(Re)semblance and Analogia: On Becoming Multiple by Listening in *Oyoyo*[1]

All of these thoughts were first formulated with Professor Doreen Mende in the context of the research project *Decolonizing Socialism: Entangled Internationalism* in Geneva. Professor Sónia Vaz Borges guided us through the translation of the song "Oi Oi Oi," and Lea Marie Nienhoff helped generously with the transcription and translation of subtitles. The cinematographer of *Oyoyo*, Lars Barthel, helped by providing interviews and historical details. Various archives helped with particular sources, permissions, and contacts—the archive of the Hochschule für Film und Fernsehen der DDR (HFF, The Film and Television Academy of the GDR) Babelsberg, those of *New Age Weekly* (the Central Organ of the Communist Party of India), and the National Film Archive of India—as did Priyakshi Agarwal and Mallika Sarabhai. We also shared afterthoughts in *The New Alphabet School*'s "Community-Building" film workshop. In the spirit of Fred Moten's words, I "consent not to remain a single being"[2] in the writing of this contribution. The fragments of personal memory and historical research events from the film intertwine with each other and become metaphors together. They form a multilayered shape, suspended and hidden between the numbers and points that remain to be revealed to each reader subjectively.

1.

Tungalag Sodnomgombyn ULAANBAATAR
Emilio Fernandez CONSEPCIÓN
Carlos Neto BOLAMA

Irene Blanco LA HABANA
Mario Chavez Landivar SANTA CRUZ
Afonso Semedo PRATA

A song fades into the background (Nara Leão, "Minha Nêga" from the 1969 album *Coisas Do Mundo*). In the end, there is a log of names and places. Places which have acquired other names and names which belong to some faces that have become blurred—and in some cases, disappeared.

1 Chetna Batuk Vora (dir.), *Oyoyo*, submitted as part of a degree course at the Hochschule für Film und Fernsehen der DDR, 1978; projected in 1980.

2 Fred Moten, *The Universal Machine (consent not to be a single being)*. Durham, NC: Duke University Press, 2018.

Emma Korouma ségou
Manuel Coelho Mendonça vorela
Ansoumane Mané bissau

Carmen Maria Barbosa e Sá
José Júlio Delgado bissau
Carlos Monteiro Cardoso

Monica Mateluna santiago
Theodros Alemu addis abeba
Georgos Loumiotis athenái

Isidoro Rodrigues Junior
Alcina Garez Barbosa bissau
Silva Auzenda

Beratung Ullrich Weiß
 Egbert Lipowski
Mitarbeit Volker Werner Ton
 Petra Heymann Schnitt
 Jama Haji Adan Production
Gestaltung Lars P. Barthel Kamera
 Chetna Batuk Vora Regie

Hochschule für Film und Fernsehen der DDR
© Fernsehen der DDR
1980

Only the sound from the film remains with me: "Oi Oi Oi Oi / Oi Oi Oi Oi Oi."

The letters of the names acquire the slow movement of the figures who were dancing just a moment before; I acquire an exteriority as the scene now appears within a window.

Apart from some names that you can associate with figures in the film, you cannot place precisely who was who and where each person was from in the film. They overlap. They are proximate. They juxtapose. They become multiple. All you are left with is a feeling of having been very close. Contaminated with a desire for a world. In a world between their friendships, conversations, laughter, dances, recountings, journeys, philosophies, and worldviews, one undergoes a process of fractalization and frottage, and semblances acquire a character of déjà vu, as one becomes multiple.

In the last two flickering moments of this ending, I read: "Chetna Batuk Vora—Regie," "Hochschule für Film und Fernsehen der DDR/1980."

2.

"They were our friends," the cinematographer of the film, Lars Barthel, told me during an interview. "They used to visit each other's places. Some of them studied Political Economy while others studied Medicine. Others still, like Chetna, studied Film Direction, and *Oyoyo* was Chetna's final submission for the year before graduation."

All the international students of the HHF took German upon arrival as a mandatory course for at least six months to one year before moving into their different courses. So, German became a lingua franca amongst students speaking Vietnamese, Cape Verdean Creole, Gujarati, Portuguese, Hindi, and English. Yet, a lingua franca is an unstable common ground, and it cracks under the pressure of friendship. Its linguistic hegemonies are undermined in the film in creole songs, words in other languages inserted into German sentences, glances, gestures,

and utterances as people move in and out of this lingua franca.

The opening scene of *Oyoyo* is an exterior of the building in Berlin-Karlshorst. When we turn towards the interior, there is a long corridor with rooms on either side.

3.

January 9, 2018. It was my first visit to Berlin, and I arrived at the Haus der Kulturen der Welt (HKW) building among a group of people from everywhere. Artists, curators, and other students like me. We had our breakfast, and we assembled in the main hall where there was a temporary structure that had curtains with which we could create the spaces we needed. We were organized into different streams; I was in the "Translation" section. We quickly shared our questions: why does unlearning still resemble a learning; why in the end must we present our work; what do "we" want to do as a group; what does our coming together from different fields and places mean—we started to formulate a friendship in our concerns.

Slowly, as our bodies inhabited the same space, as we endured long sessions, as our need for breaks aligned, as we shared with each other our work and ideas, and as we noticed each other's wayward movement across buildings and out of them, we became linked. Many of us have stayed and thought together since. We visited each other's homes, did projects together, and shared our anxieties and joys. Slowly, we came to inhabit a world that is formed within our togetherness. That morning in Berlin had long-term implications that I didn't expect at the time.

4.

There is a song in the middle of the film from which the title derives: "Oi Oi Oi Oi." The song remains as a refrain throughout the rest of the film. Right after the song, there is a conversation between Chetna Vora, the director of the film, and Carmen Maria Barbosa e Sá, a student from Guinea Bissau. Chetna is behind the camera and Carmen is in front of it. Carmen says that her grandfather, who was a merchant, came from India. Her parents, like her, were born in Guinea Bissau. She can't remember the name of this grandfather though, as she was born a year after he died in 1956. Carmen says she would like to study medicine for six years and then go back to Guinea Bissau sometime in 1983/84. "It takes a long time," she says.

5.

I am confronted again and again with the inherent conflict between the politics of archives and those of friendship. Friendships, unlike archives, are not a function of space-time. They seem to exceed time and leak across the kind of spaces that are so often confined in archives. The time periods of *Oyoyo* are both historical (1976-78, when the film was directed) and projected (1984, when Carmen would return to Guinea Bissau and Chetna to India), which exist within and outside of the film.

I am here in Lisbon now, trying my luck at the Amílcar Cabral Foundation, asking different people if they know of Carmen Maria Barbosa e Sá who once studied Medicine and German in the GDR. In a way, this film is an archive—everyone in the film had their lives before, in anticolonial movements, and they went on to have their *afterlives*. Each of these lives are different documents, maps of routes and paths that intersect at this one point: *Oyoyo*. But the analogy of this film as an archive does not suffice. Any imagination of archive,

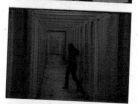

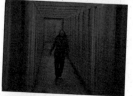

arkhe, seems insufficient, even counterproductive, as this film infects the viewer with a desire today for a possible tomorrow. It is far too immediate for me.

Like this gallery of rooms here in *Oyoyo*. These cabinets may resemble a physical archive, but the presence of this student, walking in and out of these doors, proves the incapacity to fully capture this moment. And in their absence, we come to think of those who have been here before.

6.

It is another day in *The New Alphabet School*, and I am late. I arrive, and there is a bodily formation that is taking up space in the main hall. Suddenly, a hand pulls me in. What is this exercise? What does it mean to participate in this? I give in and follow.

7.

A hesitant moment. The inward turn of internationalism between Chetna and Carmen. Internationalism, despite internationalism, yet internationalism—as they did it only between them.

8.

Oyoyo was Chetna Vora's submission for the year before she graduated from her studies at the HFF in Potsdam. Her final-year submission, *Frauen in Berlin* (*Women in Berlin*), was never officially accepted as a film completed at the school. The production of *Frauen in Berlin* was canceled at the rough-cut stage at the direction of HFF management, and the negatives were mostly destroyed. The label on the back of the DVD copy of *Frauen in Berlin* states:

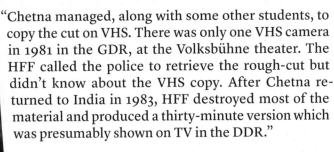

"Chetna managed, along with some other students, to copy the cut on VHS. There was only one VHS camera in 1981 in the GDR, at the Volksbühne theater. The HFF called the police to retrieve the rough-cut but didn't know about the VHS copy. After Chetna returned to India in 1983, HFF destroyed most of the material and produced a thirty-minute version which was presumably shown on TV in the DDR."

9.

I learn from *Oyoyo* that, between friends, love seems to take an alien shape. It is a descriptive act to belong to something that is indescribable. Yet, more than an object of love, the film is a recounting between Carmen and Chetna and their friends, describing themselves in the state of being in love. And as Chetna is reassembling love for herself, something alien transpires from the screen, the screen breaks in its inability to seize the moment. As if the screen was a nation-state, and the camera a colonial paradigm.

10.

There are friendships formed out of friendships and communities out of communities, like an endless loop. Something remains, while something changes. It is one of the ways the multiplication of being takes place.

Once upon a time, there was a hostel in Berlin-Karlshorst in which Chetna Vora shot a film called *Oyoyo* and each time I watch it, it turns within me a whirlpool of desire for internationalism as an anticolonial possibility, a world of our own that I keep on naming as "friendship."

Subtle Bodies

What would the world look like if everyone had full autonomy over their bodies? The question is teetering with cursory ambiguity but freighted with practical challenges. The non-consensual (and inappropriate) extended gaze from a manager or the urge to tattoo flower petals on one's arm are echoes of the range of ways that people navigate their sovereignty. The extent to which our bodies are wounded, molested, respected, and admired is also rooted in the privileges and exclusions we have historically inherited. Current assumptions about ethnicity, class, sexual orientation, and gender, all shape—in critical ways—which bodies are given autonomy, and which may find themselves subjected to captivity. For African American women, being able to exercise full freedom of movement, swim in a river, make love to one's suitor, or even terminate a pregnancy were historically denied, a precedent that speaks to how American society has thwarted Black women's freedom. "One thing we all agree on, and the real purpose of Black feminist thought, is our desire to be ourselves and to have control over our bodies," Simone Leigh marveled as she reflected on her exhibition, *Sovereignty*.[1] Premiering at the 59th Venice Biennale, her mixed media and immersive exposition marshaled a celebration of Black women. As a long-time admirer of Leigh's work, I wallow in her ability to generate sculptures that possess gentleness and might simultaneously. Sprinkled with hope, admiration, and purpose, *Sovereignty* is a cavernous appeal to history that pivots toward Black women's unrelenting quest to be free.

Few artists are explicit as Leigh about who their intended audience is. In 2019, following the controversy that called into question the "radicality" of the Whitney Biennale, African American artist Simone Leigh set the record straight. She opined, "I have politely said black women are my primary audience."[2] Launching into a passionate

1 Julie Baumgardner, "At the Venice Biennale, Simone Leigh Embraces Sovereignty," *Hyperallergic*, May 1, 2022, https://hyperallergic.com/ 728992/at-the-venice-biennale-simone-leigh-embraces-sovereignty/, accessed May 30, 2022.
2 Alex Greenberger, "How Simone Leigh's Sculptures Centering Black Women Brought Her to the Venice Biennale," *ARTnews*, October 19, 2020, https://www.artnews.com/feature/simone-leigh-who-is-she-why-is-she-famous-1234574361/, accessed May 31, 2022.

rebuttal against claims that contributions to the Whitney Biennial 2019 (and by extension, her artworks) lacked radicality, Leigh conjured her position through deft prose, gracefully outlining the historical and political references that were carved into her work: a self-styled genealogy of Black history transcribed through art and philosophy. With acute precision, she referenced Saidiya Hartman, Hortense Spillers, Black Feminism, Négritude, Katherine Dunham, Benin bronzes, and the Herero Genocide. By casting her inspiration into the digital sphere, she redirected her care from a general audience to one of the most marginalized groups in America.

How do we make sense of art whose meaning goes far deeper than what the critic can comprehend? The question, of course, is loaded with the assumption that art is intended for everyone, that it serves an intellectual purpose, or that the function it serves is ubiquitous. Leigh's work extends beyond the critic and carves a space for new communities to form. With tenderness, Leigh manifests a radical body politic through her ability to grasp deep history, social injustice, and revolutionary thought, not just as a rhetorical practice, but to capture the thoughts, minds, and spirits of Black women.

Shifting the perspective of art and its focus from the critic to the subject, it cannot be refuted that Leigh's work is incontrovertible and that her ingenuity has a great effect on the moral imagination. Over the course of the 2019 Whitney Biennial, the museum kept busy, adding hundreds of works to the program that addressed the vision of curators Jane Panetta and Rujeko Hockley of engagement in "thoughtful and productive experimentation, the re-envisioning of self and society, and political and aesthetic strategies for survival."[3] Leigh's work was undeniably part of their curatorial reverie, a leitmotif of Black women's reimagination and survival. Altogether, she provided three sculptures for the Biennial, and of the three, I was particularly infatuated with *Stick* (2019), which presents a partially nude Black woman, breasts bare, with her head slightly bent, and arms severed, cut shortly below the shoulder. Her lower half, a dress from which spikes emanated. I was struck by the differentiation between the upper portion of her body, which was exposed and vulnerable, and the

3 Jane Panetta and Rujeko Hockley, Press Release, "Whitney Biennial 2019: Curatorial Statement," https://vielmetter.com/exhibitions/nicole-eisenman-2019-whitney-biennial, accessed May 31, 2022.

lower portion of the sculpture which functioned as a shield. Although the upper half of this Black woman's body appeared vincible, the lower half was a fortification that appeared to protect her. What is inviting about the piece is its covert and overt references. According to Leigh, "architecture is a text that we can read to understand the ontological, philosophical, and psychological expressions of culture,"[4] meaning that West African references such as the Afro and spikes have an aesthetic pull that centers Black natural hair and the bronze armory that has protected West African kingdoms. By drawing the reader between

Simone Leigh, *Stick*, 2019, Bronze, 216 x 160 x 160 cm

4 Rianna Jade Parker, "What We Carry 'in the Flesh': The Majestic Bodies of Simone Leigh," *Frieze,* no. 4 (June 2019), https://www.frieze.com/article/what-we-carry-flesh-majestic-bodies-simone-leigh, accessed May 30, 2022.

the fragility and vigor that emerge for Black women, Leigh celebrates Black beauty and the underappreciated feats of the Benin kingdom.

By using bronze for *Stick*, Leigh pays homage to the metal's significance for the Benin Empire (present-day Nigeria), intricate and prized sculptures that were stolen by British and German imperialists during the late nineteenth century. As African anticolonial activists continue to demand restitution for these stolen artifacts, Leigh's sculptures provide some emblematic reprieve. They are an artistic footnote that, despite colonial dispossession of African art, one can rejoice in pre-colonial African art history by inciting the material and aesthetic features of the Benin bronzes. Very few artists describe who their figure is, but what Leigh was doing was bringing historical depth to her radical *gestures*, her artist-activist bent, highlighting the groups that are consistently disadvantaged in the system.

Born in Chicago in 1967, Simone Leigh is an artist whose intuition and innovation have transformed the visual landscape of the contemporary—in part because she makes no concessions to her critics. Leigh is someone who portrays Black people, not solely as aggrieved objects, plunged into despair, but as unbounded majestic subjects exercising their freedom. From large-scale sculptures to experimental films, Leigh's work is arguably richly exhilarating and undergirded by the spectacular. Whether we encounter a three-dimensional figure or a community-oriented workshop, Leigh's praxis is alluring because it is committed to remembering, reconstructing, and reconvening even as the far right in the United States is committed to a convenient historical forgetting.

In 2022, Leigh made history as the first African American woman to represent the United States pavilion for the Venice Biennale. Her international recognition is unwavering, given that she is an avid artist who steadfastly puts community into her projects. That is to say, production is not just a visual choice, but it is grounded on collaborating with intellectual powerhouses, most notably, African women scholars who center on the respectable and wayward lives of Black women. Leigh moves into different contexts, communities, and practices of art outside of the commercial art world. When Leigh was asked to be involved in the 2018 Whitney Biennale, she included African American scholars Saidiya Hartman and Tina Campt among her inspirations. In short, echoing the intellectual labor of Black feminist writers offers critical and caring lexicons that elegantly and wryly dismiss antiquated

tropes about Black folks.[5] This work is not solely relegated to academia. The truth is, Leigh has a keen appreciation of the Black working class, and she shows how kinship is a major feature of her art.

Intriguingly, Leigh stands apart in her practice of care, and this is made especially visible in her 2014 project *Free People's Medical Clinic*, an artistic exploration of the United Order of Tents, a secret society of enslaved people. Founded in 1867, the society was mostly comprised of Black women nurses who provided care to everyone, irrespective of racial background. Moreover, *The Free People's Medical Clinic* evoked the spirit of the Black Panther Party Clinic by bringing care directly to people in Brooklyn. As a social health project and in collaboration with the Weeksville Heritage Center, the Stuyvesant Mansion in Brooklyn was converted into a medical center that offered free health screenings, acupuncture, HIV testing, instructions on herbalism, and yoga. This was a radical undertaking that activated the ongoing discourses of care in Black majority communities in a country that often disrespects and devalues Black Americans—in and outside of medicine. In addition to being based on the United Order of Tents, *Free People's Medical Clinic* was also based on the revolutionary care work of the Black Panther Party, which also established free clinics for its community.

Leigh is part of a larger group of Black women artists who weave the body and history into an aesthetic landscape. Speaking to the *New York Times* she said, "I feel like I'm a part of a larger group of artists and thinkers who have reached critical mass. And despite the horrific climate that we've reached, it still doesn't distract me from the fact of how amazing it is to be a Black artist right now."[6] But even more im-

5 Texts that capture new forms of Black feminism in the United States and Europe include Brittney Cooper, *Eloquent Rage: A Black Feminist Discovers Her Superpower*. New York: St. Martin's Press, 2018; Akwugo Emejulu and Francesca Sobande, *To Exist Is to Resist: Black Feminism in Europe*. London: Pluto Press, 2019; Sarah J. Jackson, Moya Bailey, and Brooke Foucault Welles, *#HashtagActivism: Networks of Race and Gender Justice*. Cambridge, MA: MIT Press, 2020; and Saidiya V. Hartman, *Scenes of Subjection: Terror, Slavery, and Self-Making in Nineteenth-Century America*. Oxford: Oxford University Press, 1997.

6 Hilarie M. Sheets, "Simone Leigh Is First Black Woman to Represent U.S. at Venice Biennale," the *New York Times*, October 14, 2020, https://www. nytimes.com/2020/10/14/arts/design/simone-leigh-venice-biennale. html, accessed May 30, 2022.

portant, her pieces explicate the social history of the United States while exercising empathy for Black women. She demands visibility for people who are often overlooked and offers them the opportunity to occupy spaces that were not designed for them but in a collective manner.

In *Brick House* (2019)—part of the series "Anatomy of Architecture" that merges the human body with tropes from African vernacular architecture—she casts a Black woman into a larger-than-life form, a prodigious flare that arouses awe. *Brick House* appears uncomplicated as a partially faceless Black woman with two braids, but it is more than that. The bodice of *Brick House* is informed by the homes and dome-shaped structures of the Batammaliba people in Togo and the Mousgoum people in Chad and Cameroon. But the piece also references various other things, including African architects and a Black "mammy," showing how sculpture is deeply embedded into the ontological and transnational expressions of various African diasporic cultures. The series are sculptures that carve out Black women in their full beauty, and in their form, how the monuments—and by extension Black women—were made to resist the prejudices of society.

Simone Leigh, *Brick House*, 2019, Bronze, 497.8 x 289.6 cm

The scope and range of these images remind me of Kara Walker's *A Subtlety* (or *Marvelous Sugar Baby*) (2014), a seventy-five-foot sculpture of a giant sphinx at the former Domino Sugar Refinery in Williamsburg, Brooklyn. Larger than life, it's a loud declaration brimming with synesthetic possibilities—Black women can take up space. Both *Brick House* and *A Subtlety* tower over the viewer, but *Brick House* commands a propitious power through its tough bronze exterior, while Kara Walker's *A Subtlety* has a fragility given that it is made of sugar. Both represent African American women being able to exist freely and as the artistic muse, with unabashed beauty. It is not lost on many Black feminists that racism and sexism impact desirability and often leave many Black femmes outside of the realm of art—even in LGBTQ spaces. As Jennifer C. Nash notes in *The Black Body in Ecstasy*, Black women's appeal is inextricably linked to the aesthetic, erotic, and sexual, and Black feminists have tried to destigmatize pleasure by documenting the various lexicons of desire within the personal and work lives of Black people.

Kara Walker, *A Subtlety, or the Marvelous Sugar Baby, an Homage to the unpaid and overworked Artisans who have refined our Sweet tastes from the cane fields to the Kitchens of the New World on the Occasion of the demolition of the Domino Sugar Refining Plant*, 2014, polystyrene foam, sugar, approx. 10.8 x 7.9 x 23 m

Both Walker and Leigh incorporate vernacular objects into their lexicon, drawing a large public audience to look at Black subjects head-on. Yet, even more important is where we see them and how those spaces represent the transformation of transportation and labor under late capitalism. The High Line—a former New York Central Railroad on the west side of Manhattan—was fully operational by 1934, transporting millions of tons of meat, dairy, and other produce. When cars and trucking overtook rail freight as a means of transporting goods, the train line deteriorated, and now the site serves as a park. Similarly, the Domino Sugar Refinery was built in 1882 in Williamsburg, Brooklyn, a working-class neighborhood along the East River. Until 2004, workers there converted dark sugar molasses into white sugar. Like the High Line, the factory has been designated as a landmark of New York City, and part of the city's "redevelopment" project.

What these artists go to show has been best described by John Berger: "Art, when it functions like this, becomes a meeting-place of the invisible, the irreducible, the enduring, guts, and honor."[7] Their sculptures sit with serenity, highlighting a moral clarity of how cities and their populations undergo socioeconomic change under capitalism. Despite these being sites of socio-environmental destruction, they reframe the narrative, enlivening the spaces, and centering the place of Black women. Leigh and Walker cast Black bodies, and by extension, Black people in a new light: a receptacle of beauty, pushing against the racist associations that have been levied against them.

An artist who represents similar wrongdoing is Wangechi Mutu, a Kenyan artist noted for her works that conflate gender, race, and the speculative. Her series, "Histology of the Different Classes of Uterine Tumors" employs the terminology of medical pathology, gesturing toward science fiction with an Afrofuturist theme. The series of drawings comprise Black female flesh, textured with attenuate photographs and drawings, and assigned pathology. It reads as an anomaly, and in one of the sets, a distorted face is occupying the center of the image, while embedded into cervical hypertrophy. The image can be read in many ways, and it asks how we see Black women's bodies and how they get pathologized or even objectified in medical settings. The broader intersectional elements of the author's identity, the content

7 John Berger, *Ways of Seeing*. London: Penguin Books, 1972, p. 9.

of the original script, and the weight of grieving, no matter a person's sexual orientation, gender identity, class, and race.

Like Leigh, Mutu's work draws attention to Black women's bodies, furnishing a silhouette of medical drawings and anatomical histories that remind us how frail the body can be. But more importantly, Mutu invariably depicts the physical burden that is explicitly imposed on Black women's bodies whether it is the history of forced reproduction or coerced sterilization.

In another artistic rendition of care, *The Waiting Room* (2016), Simone Leigh also wrestles with Black healthcare and more specifically the ways that Black women have been disadvantaged. Presented at the New Museum in New York, the work honors Esmin Elizabeth Green, a forty-nine-year-old African American woman who died after twenty-four hours waiting, neglected, in a New York City hospital receiving room. While this tragedy was central in highlighting the injustices faced by Black people in the American medical system, *The Waiting Room* was not just about the tragedy. Rather, the exhibition was meant to stimulate healing in working-class, Black communal spaces. Primed and braced for the community, the classes, free museum days, and the aliveness that is possible when care is centered on Black communities, *Waiting Room* is both collaborative and performative in that it opens space for the patrons of art to participate.

Some motivations for producing art are to provide insight, displace anxiety, and misdirect the eye from the mundane to the spectacle of life. For many good reasons, the vocation of art can also be founded in rebellion; likewise, it can be aligned with the elite. Art indulges, both intermittently and imperfectly, a psychological desire to move beyond the arbitrary boundaries of life, and Leigh, in her willingness to expand the notions of beauty, can center people who have been historically overlooked. While her work has been applauded by the upper-echelon of the art world, her work invariably ends up speaking directly to her muses—Black women. Of course, the work can and should speak to other people, and in a way, the political statements, the history, and the aesthetic choices have the potential to move the soul. Simone Leigh shows us that art, in its complexity and beauty, can unfurl the restrictions that are often placed on Black women's bodies.

To Re-member to Not Forget

A Toolkit to Exercise Our Political Memory:
Punk Altars, Radical Ancestors, and AntiFascist Spirituality

One of the most dramatic losses I experienced as a teenager was not the fading of the gigantic country of my origin, the Soviet Union; instead, it was the demise of Viktor Tsoy, the leader of the band, *Kino*, a rock star, the last romantic of an epoch destined to disappear. In those turbulent times that were the late Soviet, he was the king of our thoughts and desires, and an entire generation was listening to his songs, celebrating doing nothing, hanging out, being cool and lonesome. His lyrics were light and ironic, and yet iron-serious, with that dark, English new wave fleur. He was also one of the few who pierced the heavy, and I mean lead-heavy, atmosphere of the civic silence during the Soviet invasion of Afghanistan.

He died in a car accident. He had just turned twenty-eight. I was what? Thirteen, fourteen?

Overnight, spontaneous memorials—the *Stena Tsoya* (Tsoy's Walls)—appeared in every city, all over the country. Each of these walls was a palimpsest mottled with quotes from his songs, naïve drawings, and posters. Candles burned day and night. Fresh carnations layering over the withered ones. Precious cassette tapes and cigarettes, "deficit" rouge lipsticks (at the time everything was scarce) were offered at the altars. Someone with a guitar was always there, and together we howled Tsoy's songs. We were all mourning him.

Stena Tsoya was our refuge, and somehow became my punk university; here, I started to learn how to think, be, and act otherwise, and learned some basic guitar-playing tips, too. That was the first time I experienced the practice of collectively making an altar, and how potent these shared spaces are in creating a sense of community, a bond, a way to hold the memory alive, together.

For Chto Delat the question of memory is central. In our work, which is based on collective processes, we often include (or depart from) personal, intimate, and biographic memories, those that we embody and which populate our everyday life, as well as our collective, situated, historical memory. There is an exercise we often propose when we start to work with groups, which invites precisely this tension between the personal and the political, that we call *registra-*

tion. It is a way to let our relationships to time and space, to the past, present, and future possibilities emerge. Nina Gasteva introduced the *registration* exercise while we were working on the film *The Excluded: In the Moment of Danger.*[1] The participants of this *learning film* were invited to register themselves in the moment of danger, according to their own time and space coordinates.

1 Chto Delat (realized in collaboration with graduates of the Chto Delat School of Engaged Art), *The Excluded: In the Moment of Danger,* directed by Olga "Tsaplya" Egorova, choreographed by Nina Gasteva, 2014.

What: January 19th Antifascist Memorial Workshops

With: January 19 Committee, antifa activists, intellectuals and artists such as Haim Sokol, EliKuka, Kirill Medvedev, Olya Kurachova, Dima Green, among many others who prefer to remain anonymous

Where: Moscow and St. Petersburg

When: January 2010–ongoing

How: On January 19, 2009, two antifascists were assassinated by neo-Nazis in the center of Moscow. Stanislav "Stas" Markelov was a dedicated eco-activist, anarchist, and a very successful young lawyer who had won many important court cases defending so-called "street antifa" activists. Anastasia "Nastya" Baburova was an anarchist activist and a journalist for *Novaya Gazeta.* Both were shot and killed. Ever since, the art collective Chto Delat has participated in an annual antifascist memorial march dedicated to them. By hosting a workshop to make an altar-on-the-march, Chto Delat commemorate Stas and Nastya and other antifa militants killed on the streets in the early 2000s, as well as the migrants and workers who have been assaulted, the partisans of the Second World War, and all those who have perished fighting fascism.

For example:

> Ilya: *I'm 2,000 kilometers from the battle for Donetsk Airport and twenty years away from the first war in Chechnya.*
> Anya: *I'm 700 kilometers from the place of mass protests at Bolotnaya Square. I wasn't there on May 6, 2012.*
> Tim: *I'm ten fingernails on the map from the destroyed monument to Lenin in Zhytomyr, Central Ukraine. And forty-nine years after the first artificial satellite was launched from Earth.*

Following this practice, I am writing this text one Russian warship away from the start of the war,[2] and 4,5567 cables[3] away from my children. We are well aware of the ambivalence between commemoration and memorialization, the complex issues of documentation and representation. We resist monumentalizing, or historicizing memory; rather,

2 On February 24, 2022, the Russian flagship missile cruiser, *Moskva*, began its assault on Snake Island, Ukraine, an island located in the Black Sea. During the onslaught, the *Moskva* called on the soldiers to surrender. The exchange has been translated as follows:
Russian warship: "Snake Island, I, Russian warship, repeat the offer: put down your arms and surrender, or you will be bombed. Have you understood me? Do you copy?"
Ukrainian 1: *"That's it, then. Or, do we need to fuck them back off?"*
Ukrainian 2: *"Might as well."*
Ukrainian 1: "Russian warship, go fuck yourself."

3 One cable (international) = 0.1852 km / 0.1 nautical mile.

What: Altars to Our Teachers: Chapter 1

With: Participants at the IV Ecoversities Planetary Gathering, convened with Daniela Brasil, Kate Morales, and Alessandra Pomarico

Where: Michoacán, Mexico

When: Día de los Muertos (Day of the Dead), 2019

How: The Ecoversities Alliance reunited in Michoacán, land of the Indigenous Purépecha people, controlled today by the drug cartels. Whilst participating in the tradition of Día de los Muertos, when people welcome back those who have passed, we proposed the building of a common altar. With many friends versed in the arts of opening portals, creating garlands of flowers, *papel picado* (paper craft), and preparing offerings, we called back our beloved and the teachers who paved the way for our radical pedagogies and those who fought to defend life. We shared stories, songs, poems, invocations, tears, and sentiments. We stood in silence, we danced, we embraced. We got to know and to mix with our ancestors: Paulo Freire, Berta Cáceres, Marielle Franco, Comandanta Ramona, Joe Strummer, Micha the cat, and Nonna Mimma, Nastya Baburova, Stas Markelov, and the forty-three students of the Rural Teachers College of Ayotzinapa, *presente!*

it is a matter to discuss, question, reflect upon. In this sense, the practice of making altars collectively appeared more as an instrument to host spaces of remembrance, revocation, militant mourning, and reclamation. Secular yet sacred, these are spaces where our political and spiritual legacy can be named, *re-membered,* and passed on.

In Chto Delat, what we claim as our ancestral lineage was never directly or exclusively connected to our relationships with either bloodline, soil, or nationality; on the contrary, we consider our ancestors those who (in-)formed us, and thanks to whom we can all engage in a constant process of becoming ourselves. We often call for Rosa Luxemburg and Alexandra Kollontai; bell hooks and Audre Lorde and Langston Hughes; Brecht, Boal, and Freire. We share these teachers with many others, across different locations and contexts—they paved our path.

We also evoke as teachers those who fell victim to Nazism, femicide, state-violence: Carlo Giuliani, Nastya Baburova, the miners of

Listvyazhnaya, the Communards who have been executed, those killed on Maidan in Ukraine, Marielle Franco, "Vanya Kostolom" Khutorskoy, Loukanikos the dog. They are our lighthouses, sending us those *weak signals of hope*;[4] their light transcends time and space, overcoming the borders—linguistic or territorial—their lessons are sown into us. Their seeds have grown roots, becoming places of our radical belonging. They deliver strange flowers, bring hybrid fruits that taste bittersweet at times.

We saw some altars become monumental, while some monuments became altars. Some memories tend to vanish, some persist on

4 Chto Delat, *It's Getting Darker: Lighthouse—Memorials to the Weak Lights of Hope,* mixed-media, various dimensions, 2015-21. The installation followed and includes the film by Chto Delat, *It Hasn't Happened to Us Yet: Safe Haven,* director Olga "Tsaplya" Egorova, choreographer Nina Gasteva, 2016.

What: Altars to Our Teachers: Chapter 2
With: The second international gathering of Under the Mango Tree, hosted by Sepake Angiama, Tara Lasrado, and Sanchayan Ghosh
Where: Santiniketan, West Bengal
When: January 2020
How: We reunited in the legendary Visva-Bharati University founded one century ago in Santiniketan by the great poet and pedagogue Rabindranath Tagore. The university was one of the most radical pedagogical experiments of the time, integrating arts, crafts, and humanities for students, regardless of caste. Our second Altar to Our Teachers was built to honor those who have inspired, transformed, and influenced our pathways. Stories of different struggles were shared, and social structures were questioned—as were forms of state-led fascism against different religions and tribal communities in India and issues around enclosures and land appropriation, ecology, queerness, and feminism.

↑ Taylor Cruz recites *Soy Animal Triste,* a poem by Angela Marìa Dàvila

our flesh, in our bones, and between our neurons; we know, some memories have been stolen, silenced, mis-interpreted, or misused: violated for the sake of serving the powers that be. Some are revolting and resurrecting, they find a place to become visible again, they are reclaimed, performed, transmitted.

For a long time, with Chto Delat, we investigated monumentality and built temporary collective memorials or *counter-monuments,* some so vulnerable and fragile that they have been burnt down and disappeared in one night. Back in 2014, and so many times after our *Queer Antifascist Soldier* was set alight in Berlin (during Russia's first invasion in Ukraine) we had to ask ourselves how to keep our antifascist memory alive and present.[5]

5 See page 63 for Chto Delat, *Altar to Antifa of All Times and Cultures,* 2014.

What: **Altars to Our Teachers: Chapter 3**
With: Visitors to the exhibition *Times, Lines, 1989s*
Where: CAC, Glasgow, and Khoj, New Delhi
When: 2019–20
How: Chto Delat included an altar in their solo show *Times, Lines, 1989s.* By setting up "A History Making Station" (a computer connected to a printer and Wi-Fi), they invited the audience to participate through adding their own key figures or historical events into the porous structure of the exhibition. This is how Gilles Deleuze, a giraffe, Ivan Illich, and Tzaplya's mother Zoya found their place within this ten-meter-high, capsular-vascular tangle memorial.

↑ Ceremony of the activation of the Altar at Khoj. Nikolay Oleynikov invokes ancestors by invoking each of the ancestors' names, their desires [*nadezhdy*], their beliefs [*vera*], and the cause of death for each of them.

Right now, Putin is employing his expression *denazification*—a neologism of his own invention—to justify the atrocities of the occupation of Ukraine. Will it ever be possible to reclaim our political memory, to speak out about our antifascism, to un-foul it from layers of gross lies, outrageous crimes, and horrors? What does it mean to remember and not to forget?

In Russia, we have witnessed how the state has appropriated the history of the victory against Nazi-fascism, manipulating people's individual memories, appropriating the antifascist rhetoric in a revisionist way, to justify, for example, the annexation of Crimea eight years ago. We are witnessing now, history casting a much heavier weight, something that we saw coming but could not be well enough prepared for to face and confront. How do we remember an event that is rendered unnamable by official narratives, and unspeakable by a collective wound?

What: **Altar to Miners and Canaries**
With: **The School of Engaged Art, St. Petersburg, and the students of the research course led by Ernesto Oroza at École Supérieure d'Art et de Design, St. Étienne**
Where: **ETOZDES and Rosa House of Culture, St. Petersburg**
When: **December 2021**
How: *Testimonies of the Canary* is a large-scale collective wall-painting that was created after a year-long artistic research project on Dangers and Catastrophes—and those sensitive beings who send us signals of alert. We were inspired by the phenomena of the "canary testimony." The canary is a sentinel bird with a fast metabolism; when exposed to high methane levels in a coal mine, it dies, signaling the miners to immediately evacuate. As we were working together on November 25, 2021, we heard of an explosion at the Listvyazhnaya coal mine in Russia, which killed fifty-one people. Following this event, we embedded as part of the mural an altar dedicated to all miners and canaries fallen at work. The altar was also activated with the *Danger Choir* performance and a night-long rave vigil.

↑ Mother Earth Eats Her Beloved Children—the Coalmine Workers. Wallpainting: Alisa Mak (fragment of the Altar to Miners and Canaries)

Celebrating the memory of our dead, re-signifying the public space through assembling our bodies, voices, memories, and songs, or collecting items to insert inside a time capsule to send to future generations (hoping they will not repeat the same mistakes)—these are ways for Chto Delat to resist or, in other words, to ensure our *survivance*. Developing a participatory method of making altars and *counter-monuments*, we have been trying to activate a politics of space—of encounters, of collaborative interactions—to share our experiences and desires, to strengthen a sense of belonging. Some of these altars were built outside, in public space, in emblematic sites of struggles, or in places where people commonly gather; at other times, the altars appeared inside, in art spaces, attempting to resignify these sites.

We are interested in the speculative potential and the possibility of political awareness these practices might bring, and we often associate them with storytelling, place building, and filmmaking. In this

What: **Altar to Antifa of All Times and Cultures**
With: **Into the City festival, curated by Birgit Lurz and Wolfgang Schlag, and inhabitants of Vienna**
Where: **Schwarzenbergplatz, Vienna**
When: **May 2014**
How: **Chto Delat's project *Face to Face with Monument* revolved around the politics of commemoration, with the aim of transforming fixed monumental structures into more ephemeral, performative, and participatory practices of remembrance. Part of our temporary monument was dedicated to the commemoration of antifascist fighters of all times and cultures. Neighbors and visitors were also invited to express their own understanding of today's antifascist struggle. Yugoslav *Partisanki* (Partisans) of the Second World War, Patrice Lumumba, John Heartfield, Bear Jew, and Antonio Gramsci were resurrected shoulder to shoulder.**

way, the practice of *commemoration* (literally, bringing our memories together) becomes a pedagogy, and the place becomes a site of learning. We make our shrines collectively, we erect our own memorials or *counter-monuments,* we activate them using our own reinvented feminist, antifascist ceremonies and offerings, we organize punk-concerts, debates, readings, raves, performances, actions, meetings of grassroots activists, or silent wakes. Our altars reappropriate monumentality via a more intimate, vernacular, and affective mode.

Indeed, for us, art (as practice and space) has to be where our living memory is present—therefore, inhabiting the streets, our homes, our schools. Bringing back those who have fought before us, our teachers and elders (no matter how young they were when they died), helps us to provide and maintain spaces for coming together, to mourn, to never forget, to name, to *re-member*; to search for where we come from, in the hope that it will give us the strength to keep going.

What: **Altar of Our Sheroes**

With: International Feminist Strike 8-M, New York City; migrant and undocumented women, sex workers, and women's trade unions; grass-roots organizations such as the Workers Art Coalition and Tools & Tiaras Inc.; and artist-activists such as Barry Cline, Danilo Correale, Nina Cossin, Shadi Harouni, Talia Molé, Olga Kopenkina, Ayreen Anastas & Rene Gabri, Alessandra Pomarico, Greg Sholette, and Athena Soules, among others

Where: Union Square Park, Washington Square Park, The 8th Floor and New York University, and elsewhere

When: 2018–ongoing

How: In 2018, in preparation for the annual International Feminist Strike on March 8 (8-M), a series of workshops were organized that mixed political prop-making technology with our altar-making practice. The portraits of murdered and disappeared women—of poets, intellectuals, undocumented workers, mothers, feminists, and freedom fighters—were displayed in public space with slogans, banners, flowers, incense, and candles. It became a tradition, and every year for the 8-M strike as well as on the International Day for the Elimination of Violence against Women (November 25), these portraits come out on to the street during vigils, festivals, and rallies.

a rhythm

To Remember Means to Fight
Never Forgive, Never Forget

In the summer of 2021, Chto Delat took part in *The New Alphabet School*'s session on "Survivance," hosted in Portugal and online. The group proposed a workshop titled "Practices of Collective Counter-Memory: Altars, Vigils, Time Capsules, and Living Monuments"—tools the collective often employs to exercise forms of remembrance, solidarity, and caring, and to practice becoming a community. Nikolay Oleynikov has reassembled some of these political and ceremonial gestures, weaving together communities of struggles across different geographies and encounters.

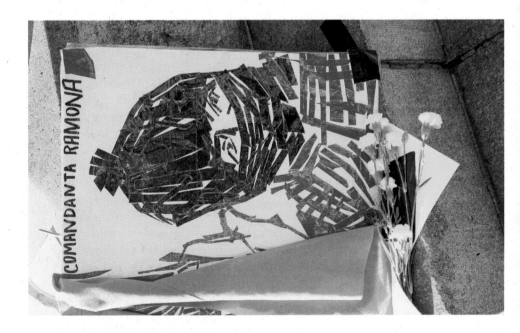

We'd like to thank Alessandra Pomarico for her precious revision of this text. Her editorial guidance made this writing possible, in a moment when things became almost unspeakable.

In the Cracks of Learning

To gather, together, to get there.

This reflection arises from the experiences and ideas collectively produced through many gatherings, shared artistic investigations, commoning times and spaces, reading groups, and walking groups, as a result of many conversations and encounters among those committed to cocreating autonomous learning spaces and supporting localized yet transterritorially connected communities of seekers. It builds on what it means to be part of a learning community that is in a continuous process of becoming, attempting to embrace radical pedagogies and wider epistemologies (that is, not necessarily Western-centric) and ecologies, moving beyond and against patriarchal, colonial, racial-capitalist relations, which so often inform existing institutions of education.

I have been trained (and at both sides of the classroom) in the traditional institutional higher education system; I also have experienced deschooled (with Ivan Illich) and radically unstructured and horizontal forms of *unlearning*, and I've been committed to introduce more convivial, at times militant, alternative methods of learning and co-researching in existing formal environments. As a curator, facilitator, and organizer, I have often worked with artists and community builders whose practices are inherently pedagogical and relational. In particular, I refer to what has emerged from the Free Home University, an ongoing artistic and pedagogical experiment co-founded with a group of artists, thinkers, and doers focused on sharing knowledge by living together in Southern Italy and responding to urgent local struggles. On a more planetarian scale, there are traces of my involvement in the Ecoversities Alliance, a transterritorial network that aims to rethink education through more just and eco-centered approaches, as well as in the more-or-less temporary experiences shared within The School of the We, co-initiated with <rotor> and its expanded community in Graz, which seeks to reinhabit public spaces in the aftermath of the first pandemic lockdown. Finally, and with particular relevance to this publication, the process cultivated during *The New Alphabet School*, which I was involved in from inception, co-curating two editions of its online publication on HEALING as a co-editor of the blog publications, as well as facilitating the final session on COM-

MONING. From each of the voices and presences, different perspectives, gifts, urgencies, and desires of those with whom I shared a process of co-creation—in an effort to also include the more-than-human communities and different forms of living and nonliving beings—I have been immersed in differently unfolding pedagogical relationships, all of them leading to a personal and collective transformation.

To engage this direction, it is urgent today to unlearn the current paradigms that are endangering the living ecosystem and to study, practice, prefiguratively envision, and prepare ourselves to follow more regenerative sets of values. In the disruptive process of reimagining, the formation of temporary autonomous zones[1] of learning is a constitutional step for the change we are called upon to produce in our times of social and ecological catastrophe. Addressing pedagogy as *politics*, sharing tools and other ways of being, knowing, and relating, attempting to build translocal solidarity within a larger network have become seminal in our times of struggle; indeed, many people and communities worldwide are already reclaiming the right to self-organize their everyday lives. It is in this legacy that I hope to inscribe my search, with gratitude and admiration for all who, in the present as in the past, sustain those "brave spaces" where sharing knowledge differently is a way to create a different world.

Renaming the World; Learning to Defend and Create Life

Pedagogy can be the very discipline that reiterates a vertical, authoritarian experience, or it can offer the possibility of emancipation, freedom, and justice. When arguing that it is urgent to rethink the education system (reforming it would not be enough), we are stating the necessity of a radical shift that may occur through the creation of a different language, opening up a new imaginary from which different narratives can arise.

The act of naming, which informs our ways of thinking, is not neutral and is based on stratifications of conventions that are historically determined. Our language contains assumptions and continually

1 The term is mostly associated with Hakim Bey, *TAZ: The Temporary Autonomous Zone, Ontological Anarchy, Poetic Terrorism*. New York: Autonomedia, 1991.

reproduces the worldview it projects. If we take a trip into the archae-
ology of meanings, in the context of the Western history of educational
institutions, the semantic and epistemological structures that inform
pedagogy (mostly focused on the act of teaching rather than on the
processes of learning) imply an uneven relationship between the ones
who "know" and the ones who don't, leading to an intrinsically vio-
lent approach for the sake of "shaping," "instructing," "training," and
"developing" the ignorant. We can find many examples in verbs and
nouns related to education that reveal the nature and structure of
teaching as an asymmetrical process of knowledge transfer.[2] Michel
Foucault included schools (together with prisons and mental hospi-
tals) among the *institutions totales* erected to repress and control the
social system, through which so many physical, psychological, emo-
tional, cognitive, and cultural traumas have been perpetuated and op-
pression reproduced. The Residential Schools in Canada are a perfect
example of this apparatus, where the systematic repression of Indig-
enous language, culture, and cosmogony—together with physical vi-
olence inflicted upon First Nation communities—has almost extermi-
nated and deeply wounded them, and it continues to harmfully
impact not only their communities but society at large.

Language has a quintessential role to play in any attempt at de-
colonizing the production of culture, the educational institutions, and
the pedagogical process. In some Indigenous native languages, only
a collective subject exists: the "we" form, which means that people
always speak from and with the community. Let us simply take into

2 The Greek and Latin etymology of the word "pedagogue" refers to the
 slave who escorted boys to school, a relationship based on differences of
 power and status; the "educator" represents "a foster father" (caring with
 authority); and the "erudite" is the one who "polishes the unskilled, the
 rude, the rough." "Education" comes from *educere*, as in "bringing out, to
 draw out, extract, branch out"; "to inform" (like in Neo-Latin languages,
 forming is used as an equivalent to educating) means "to give a shape" or
 "having power to form or animate" (whereby somebody presumably is
 without anima if not instructed); and it shares a similar root with "to
 conform" (to form according to the same rules). "Docile" originally meant
 "the one who is easily taught" (by a doctor who, in Latin, was the one who
 taught, as in "indoctrinate" or in Doctorate, the highest point of scholarly
 education); and "to teach" in Neo-Latin languages means to put "a sign on."

consideration what a dramatic change in the entire system of social relations was brought about by the introduction of the "I" persona, as well as the relative concept of individual interest, which was a product of Spanish/European colonization.

Even without these extreme examples of cultural genocide that the Residential Schools represent, many educators consider what some call the modern "factory schools"—with their principles of "common core," "skills and competencies," and standardized curricula and evaluations—as a way to imprison students' imagination, instruct them to accept social rules/roles without question, and direct their choices toward the current marketplace. Furthermore, when we use a language built on class, racial, gender, or sexual bias, the assumptions and misconceptions encoded in words become internalized and are reproduced.

Thus, the question is: How can the metaphorical nature of language support a paradigmatic shift toward pedagogical relations that refuse to reproduce oppressive, patriarchal, extractive, colonial patterns?

> Our elders say that in order to give birth to the world, we
> need to name it [...]. In this historical moment the old concepts
> are falling down and new practices are being born, where
> the words that we have are no longer useful to name the new
> world; thinking of new spaces of learning, beyond the classical
> idea of 'education': of the master and the student; of the mere
> transfer of knowledge; of the educational bureaucracy; of the
> endless repetition of dogmas. We use LEARN or LEARNING,
> reclaiming the verb that evokes the action, because we all
> learn in every moment, under diverse circumstances and in
> determined contexts, like the war in which we are currently
> situated.[3]

3 Edgardo García, "Learning to Learn in a Context of War: Notes on the 1st Ecoversities Gathering," trans. Gerardo Lopez Amaro (October 26, 2015), *Pedagogy, Otherwise*, no. 12/27 (2015), available on the online platform www.artseverywhere.ca, https://www.artseverywhere.ca/learning-to-learn-in-a-context-of-war/, accessed July 7, 2022.

If we are "planetary subjects rather than global agents," in the words of Gayatri Spivak,[4] then our stories, objects, debts, wars, resources, languages, economies, and cultures are entangled, and our destiny is interrelated.

How can we allow the emergence of a counternarrative, a shift of paradigms, a space for political, multiversal processes of resistance and re-existence? How can we create a post-neoliberal education— one that resists the principles of profit, extraction, competitiveness, and exploitation? Could pedagogy be a way to learn how to rename-re-birth the world?

The way we learn today is very much related to the way we live under capitalism, where the production of knowledge becomes a financial enterprise. When we analyze the model of American universities, exported around the globe, it becomes clear that these institutions function as corporations, organized around private financial forces, structurally propagating debt that students will take an average of twenty to thirty years to repay. If the right to study is the right to be free and have access to equal possibilities, it seems now that only a few are able to have it, and at long-lasting cost. The right to be educated, central in welfare social policies, is today the right to contract debt, or one might say, as a chain of debt is voluntarily created, the freedom to become a slave. For some, this is clearly a larger strategy of subjugation, and it is one of the reasons why students are in constant and toxic competition, ending up depoliticized as they "manage" their lives around debt and their academic career as a business, their education and the knowledge they produce thereby becoming another commodity.[5]

4 Gayatri Chakravorty Spivak, *Death of a Discipline*. New York: Columbia University Press, 2003.
5 In *Governing by Debt*, Maurizio Lazzarato points out that students in the US in 2012 had borrowed and still owed 904 billion US dollars, a number equal to over half of the public debt of Italy and France. He explains how the cultural hegemony of neoliberal universities is organized, and he situates the new class struggle as a struggle between creditors and debtors, the access to credit as a way to access debt, and debt as a new technique of power—"the technique most adequate to the production of neoliberalism's homo economicus." Maurizio Lazzarato, *Governing by Debt*. Cambridge, MA: Semiotext(e) and MIT Press, 2015.

Early radical theorists such as Paulo Freire, John Dewey, and Ivan Illich considered education central in the preparations for a systemic change in society, precognizing in their visions the cause-and-effect of industrial and postindustrial mentalities. Thus, we need to create spaces, no matter how temporary—since their autonomous, noninstitutionalized nature may dissolve and reform elsewhere—in which we can experiment with other types of relationships, reappropriating our material and immaterial conditions, as movements toward the communalization of life. Spaces open to errors, with enough time to process, reflect, digest, practice, and heal.

As criticism is easily reabsorbed by the system (Jacques Rancière suggests that nothing else is left to criticize)[6]—with academic or cultural institutions coopting radical notions as long as they exist on purely theoretical levels with the status quo remaining unaltered—we need to be creative in organizing otherwise, testing our powers to be together, exercising our capacities beyond inevitable conflicts and ruptures, and insisting on holding spaces together. Critical and radical pedagogies—oppositional knowledges, militant and convivial research,[7] insurgent autonomous zones of knowledge production, inquiries in solidarity—are not only tools to frame our analysis on an intellectual and abstract level. They are calls to action: to plant seeds, to cross-pollinate, to imagine *what is not there yet*. They reclaim a collective desire to re-engage the world, to re-enchant it as Silvia Federici suggests,[8] rewor(l)ding, proceeding in our queries, always asking questions, *preguntando caminamos* (asking as we walk) as the Zapatistas would say. We need to embolden ourselves, overcome our own disillusion and skepticism, create spaces not only to contest but also to take care and hope, to realize a new topography of the possible (with Rancière again).[9]

6 Jacques Rancière, *The Emancipated Spectator*. London: Verso, 2009.

7 More on the concepts of convivial research, insurgent learning, ecology of knowledge, epistemological diversity, and convergent spaces for temporary zones of autonomous knowledge production can be found in Manuel Callahan, "In Defense of Conviviality and the Collective Subject," *Polis*, vol. 33 (2012), https://polis.revues.org/8432, accessed July 6, 2022.

8 Silvia Federici, *Re-enchanting the World: Feminism and the Politics of the Commons*. Oakland, CA: PM Press, 2019.

9 Rancière, *The Emancipated Spectator*.

A utopian gesture is needed, not to project into an ideal future, but in the here and now. It is already happening, perhaps an invisible and gentle planetary revolution, an unfolding insurrection.[10] Many people are creating viable alternatives, experimenting with forms of living based on mutual support, assuming responsibility for the regeneration of their communities.

From the Individual
to the Collective to the Common

To nurture a different pedagogy may be one of the ways to counteract the dominant culture of destruction, the ontology of consumerism, the necropolitics, the numbness of our senses, and the apathy of our times. To create spaces for a plurality of voices, learning within diverse sociocultural groups, from different traditions, languages, and personal stories, acknowledging our positions and privileges; to deconstruct predetermined structures and reflect on how we gather, how we organize time, space, resources, and communication, how we deal with expectations, how we make decisions, how we proceed in our inquiries; to exercise nonvertical structures—and by this I don't mean having to erase the pedagogical differences that promote learning, but enabling each one in the process to occupy the position of guiding, letting authority shift; to learn, intergenerationally, transversally, intersectionally, and without compartmentalizing disciplines, avoiding professionalism and expertise becoming a divide: These and many other challenges await us when we engage actively in a process of learning with others.

Learning requires taking risks, passing through disruption, stretching boundaries, going beyond our limits, building patience. It takes effort and courage to open up to others, to include conflict, to recognize commonalities and core differences, to build trust, to venture into the unknown and the uneasy. It can be painful to share an open-ended process: We may critically reflect without ever actually undermining the system of rules and utilitarian ways we inhabit, without

10 Gustavo Esteva, "Commoning in the New Society," *Community Development Journal*, vol. 49, supplement 1 (January 2014), pp. 44–59.

letting go of our habits and control, without relinquishing the premade tools that govern our thinking and that are supposed to facilitate our gatherings. It is especially difficult to balance the sense of individuality and collectivity, the self (and even more the ego) with the "we"; it involves negotiations, even within ourselves, and an ability to share our own vulnerabilities.

One question that always comes up is how to invite ourselves and others into those "brave spaces."[11] Rather than producing the illusion of safe spaces, we are going to expose ourselves to strong emotions, ruptures, contradiction, and conflicts as outcomes of our different views and positions. Indeed, those breakthrough moments reward us with solid relationships, intelligent friendships, memorable moments, bursts of laughter and liberating crying, celebrations, playfulness, unexpected discoveries, and a sense that deeper connections are restored—or clearly severed when toxicity poisons our relationships. And that is also part of learning, integral to life, an organic process where everything that happens—even chaos itself—is part of the knowledge produced. This knowledge should include the material, the spiritual, and the intellectual parts of ourselves, and the wisdom of the body: We are channels for the energy to circulate in, we are vessels, sensing, using intuitions and emotions, learning *in* and *from* nature (to which we belong).

Living together, literally, could be a pedagogical tool, as it helps to develop empathy and cohesion, accelerating the possibility of learning from each other, sharing spaces and time: a lot of time, all the time, a time with no "in betweens,"[12] simply waking up, doing things, cooking, debating all night long, dancing, singing, visiting people, exploring, letting our "convivial investigations emerge," creating, dismantling, reassembling... It produces a state of intimacy, a poetic way to be that seems to have a (nano)political as well as aesthetic quality. Our bodies, initially separated, start to move together, a common

11 This notion appears regarding the need for setting ground rules when working around issues of social justice in: Lisa M. Landreman (ed.), *The Art of Effective Facilitation*. Sterling, VA: Stylus, 2013.

12 This expression is borrowed from artist Rene Gabri, suggesting the deconstruction of habits of productivity and the abandonment of ourselves to *dérives*, conviviality, and a situationist approach.

pace slowly emerges, a rhythm generated by one single breath.[13] Reading a book with ten, twenty people can be transformative: You not only read it *with* them but *through* their voices, their (mother) tongues, their questions and interpretations, in a constant translation, a translation of the translation, from one language to the other but also from one understanding to another. When you write a text with a group, negotiating every word, expanding the meaning, and arguing, more nuances and subtleties emerge, together with a sense of collective identification. Your voice starts to contain a multitude.

The pedagogical process becomes one of germination, a confluence of knowledge in a context of dia/multilectics and reciprocity. An ethos of care and compassion propagates, tensions unfold and may stay unresolved: We learn in that tension, maybe not to judge, but to expose and share, to discuss without being prompted to react or provide a solution. In this process, one may feel lost, but then a direction emerges as we sense the foundation of a new constituency, something that stays with us even when we seem to be isolated or burnt-out, or when we experience some failure. Mistakes, errors, false starts, controversies are all very valuable learning allies, as they are occasions for revising our frameworks and fostering critical dialogues. They can provide a sense that together we are learning something new by being, doing, and living with all our contradictions. We need to exercise our agencies, to refine our tools and languages, and to choose better technologies. We should resist feeling overwhelmed by the task, as we are in a phase of *preparation*, a process of transformation (revolution?) that takes place in time, a time in which every moment has a value.

To be fragile but still open and trusting, hopeful of the collective process, is to be in a state of "vulnerable confidence."[14] And it is

13 In *The Use of Bodies*, Giorgio Agamben refers to the concept of "use" (as ontologically opposite to the concept of "action") where bodies are no longer subjects but forms of life. Giorgio Agamben, *The Use of Bodies*. Palo Alto, CA: Stanford University Press, 2016.

14 Udi Mandel in conversation with Kelly Teamey after the 2015 Ecoversities gathering in Tamera, Portugal. A synthesis of the experience, through theirs and many other voices, can be found in Kelly Teamey, "Are ecoversitites the future for higher education?" *openDemocracy* (April 6, 2016), https://www.opendemocracy.net/transformation/kelly-teamey-udi-mandel/are-eco-versities-future-for-higher-education, accessed July 7, 2022.

exactly in this process with others (and the more-than-human others) that a radical tenderness can appear, that commitment and support develop, friendships blossom, alliances form, people fall in love, heal, build, and weave their paths together. Or it separates when this is not enough to mend what is broken. It is nevertheless in those intimate contexts that a revolutionary, radical love made of a thirst for justice, militant gentleness, and subversive soulfulness can form. There, we discover a way to fight the atomized, isolated, egocentric individual that we risk becoming in times of spiritual starvation and political catastrophe, as Cornel West argues in his beautiful *Black Prophetic Fire*, a true love letter to the next generation.[15]

Our words, once fragmented, begin to collide, and a common horizon appears—one that always finishes and never finishes, and we live together with no separation. If teaching is a process of transcending oneself into the other,[16] then learning is becoming something more (or less).

15 The notion of radical love resonates with Jacques Derrida's notion of the "politics of friendship" and Spivak's "ethics of friendship," as well as the need for a praxis built around solidarity. *In Black Prophetic Fire*, following the tradition of the theology of liberation, West reclaims this notion along with those of truth, justice, freedom, sacrifice, and death as a reaction to systems of oppression. Cornell West, *Black Prophetic Fire*. Boston, MA: Beacon Press, 2014.

16 Gilles Deleuze and Félix Guattari, *Mille Plateaux*. Paris: Editions de Minuit, 1980 (English trans.: *A Thousand Plateaus: Capitalism and Schizophrenia*, trans. Brian Massumi. Minneapolis, MN: University of Minnesota Press, 1987).

Ten Points On What We Learned
(Inspired by *preguntando caminamos* with many)[17]

Reimagining is necessary, and when done collectively, it is *lovable*. To reimagine, we need a new language; the old one is not enough and is maybe the reason why we cannot *yet* reimagine. Our imagination is in a moment of crisis, or maybe just *in between*.

Question: Can we imagine a place for letting the unexpected emerge in the cracks of the definite and the defined?
A different time is necessary. We need to build our own temporality, abandon the projection into the future and the insistence of a constant present. There are three generations before, three generations ahead, and then *us* in the middle.

Question: How can we become a meantime?
A different way of listening is needed. Practicing profound contemplation, silencing our hyperactive egos, and letting go of control and work. By always doing something, we only accelerate and reproduce what already exists.

Question: How can we allow ourselves to be bored, rest, or wander?
Making circles is generative. Concentric circles, large circles, small circles, and spirals. Making circles to discuss, meet, play, to dance and sing, to tell stories, to look at each other, to question, to find *consentment*.[18] Making circles like the Zapatistas make *assembleas*, with the

17 This exercise was written in the form of a poem as a response to the question, "What did we learn during our first Ecoversities Gathering?" I quote some tools and words that emerged in that circumstance. In particular: learning with the Earth, through different knowledge systems, and including conflict. A strong point was also made as to the necessity of abandoning established instruments of facilitation and a preference for starting from personal narratives.

18 The term, used in the sociocracy movement, refers to the difference between consensus and consent. As Vanessa Andreotti explained in a conversation with the author: "While consensus requires us to be on the same page to work together (to agree on the ends and means), consent allows us to work together in dissensus: We don't have to be on the same page, but we need to be moving together on the same wavelength."

practical aim of solving a problem and the practical result of creating a community.

Question: How to be many?

Having the children present. Letting them be and participate and learning from them. Allowing the little older to take care of the little younger. Allowing mothers and fathers, but especially mothers, to participate and not be isolated and fragmented. It helps all of us to share responsibility, circulating the gift of children and growing up together.

Question: How can we be those children?[19]

In the same way, we need the presence and the wisdom of the elders. To grow older is needed.

Question: How can we oppose a society that doesn't allow us to grow older?

As my dear friend would say, we should always include dogs: Dogs break our seriousness and always invite cuddles, playing, sweet names in our mother tongues, and running after a stick or a ball. Dogs are representatives for other species. To spend time with and cuddle a plant or a rock is an option too.

Question: How can we fall in love again?

By extension, let us try not to forget all those wonderful and not domesticated fish, wild horses, the family of beavers, and, yes, even the mice and the snails, soilseeds-stones-sand-straw-skies-snow-sounds-streams.

We are part of a larger system. Care, not exploitation.

Ecoversities as solidarity.

Question: How can we bring life back?

Practice intuition

Patience, self-reflection, radical tenderness, collectivity, build spaces of intimacy.

Practicing, what?

19 An expression borrowed from the artist Ayreen Anastas in the context of Free Home University.

Decolonizing
positioning
commoning
how?
Intersectionally!
practice slow and deep
skinny-dipping, laughing hard, singing loud
take the risk
cook for the whole village.
practice to leave and come back, to be lost
practice to a be a couple in a group, and a group in a couple
practice not knowing
practice to walk with the dead
practice to live and to die
practice practice practice!

Question: How do we want to learn?
 [...]

Question: How do we want to live?

This text reprises excerpts from "Situating Us", originally in *SLOW
READER, a resource for design thinking and practice*, eds. Ana Paula
Pais & Carolyn F. Strauss, Amsterdam: Valiz, 2016, pp. 207-25.

Feralizing

A Conversation

Agata Kowalewska: To me, the feral designates a "third space"; it remains in tension with both the domesticated and the wild, and it bears their marks but doesn't belong with them either. I see it as this perilous state, often violent and uncertain.

Thought this way, feralizing doesn't contain the promise of rewilding, of a return to something that was supposedly better—a kind of pristine, unbound freedom. So the category is useful because it's not blind to the division between the wild and the domesticated, but it looks at them through the relations of power. Does ferality mean anything to you in your work?

> **Diana Lelonek:** In many of my projects I describe abandoned spaces that people no longer use, environments that grow on post-industrial waste areas.
>
> The objects I work with are feral through abandonment; these objects stopped being dependent on people. Things like tools, shoes, clothes that people stopped using and threw into the forest. Plants and other organisms start using these objects and look for their other functions—Styrofoam becomes a rock.

AK: I like to think about your garbage-plants as feral trash that is now exerting a new kind of agency beyond human control, despite trash being the ultimate human creation.

> **DL:** Yes, these are wild, feral objects—objects that have regained their independence. They are no longer just tools, commodities in the system of overproduction. They begin to resemble putrid wood, rocks, or soil. On the other hand, organisms such as mosses, plants, and fungi begin to use these feral objects. They seek out new functions for them by creating hybrid forms of post-waste habitats. These are not easy and unambiguous relationships, they are strange—simultaneously terrifying and appealing. They are formed independently of human actions/interventions, outside the field of view. The feral objects I study are such local outlets of the global hyperobject of waste. They aren't easy to qualify—in fact, it would be necessary to find a new language to describe these interdependencies.

↑ Diana Lelonek, *post vacuum cleaner habitat* from the series "Center For Living Things," 2021, photography of the found object

← Diana Lelonek, *polymer habitat V* from the series "Center For Living Things," 2016, photography of the found object

heat

situating

In my projects, I examine and analyze this extraordinary agency of nonhuman actors. Different species of ruderal plants—the tireless, precarious laborers striving for the recovery of ecosystems—quickly begin to capture any kind of space abandoned by humans. Interestingly, wild, feral spaces such as these, which we may find in disused factories, abandoned investments, and wastelands, are called *nieużytki* in Polish—literally meaning "not in use." In fact, these spaces are used very actively by nonhumans, and often comprise a refuge for biodiversity.

Perhaps in these feral, abandoned spaces we might be able to find answers about the future and how to better live with other species.

Speculative visions of the future also appear in many of my works. For example, *Ministry of the Environment overgrown by a Central European mixed forest*, is a result of my activist practice: it was a protest against the felling of the Białowieża Forest. It's a speculative collage depicting a post-apocalyptic future: it imagines the Polish Ministry of Environment building overtaken by a forest. It's a vision of the future that awaits us, if the environmental policy doesn't change.

Anaïs Tondeur: In French, the term ferality is sometimes associated with *marronage*, especially when describing animals that have escaped or been abandoned and, as a result, return fully or partially to a state of living in the wild. This metonymy refers to the act of abandoning someone in an uninhabited place, such as on a desert island or sandbank. The term, which appeared in around 1709, has its root in the word *maroon*, attributed to runaway slaves.

For the past ten years, I have developed a photographic protocol of attention to feral beings in Chernobyl. This gathering of photographic traces of plants growing in the irradiated soil of the Zone has become a means of noticing, observing, perceiving, and giving importance to these mutant beings.

These plants are feral but have also been transformed by other feral agents: the radioactive isotopes present in their milieu of life. The two processes meet in the very body of the vegetal being. I thus call upon the radioactivity contained in the plant to compose the photographic imprint. The rayograms are the result of the exposure of the plant to light in the photographic lab, but also to the cesium-137 in the flora.

Ferality then describes the state of living beings, as well as non-living agents who react to human attempts to transform the earth and

↑ Diana Lelonek, *Motherboard Nature* from the series "Center For Living Things," 2017, photography of the found object

escape its conquest. In this context, as explored in the online publication *Feral Atlas*, the product of nuclear power plants or the burning of fossil fuels are also feral agents.[1] Radioactive isotopes hold effects beyond those they were designed and promoted to hold. Likewise of other forms of toxic waste, of other forms of pollution such as particulate matter and carbon black particles—they become a feral microscopic dust.

The *Carbon Black* project is developed through a protocol attempting to give a tangible presence to these feral agents, however impalpable.

In this photographic installation, we encounter a series of sky portraits printed with this very dust. Retracing the trajectories of these feral particles over 1,350 kilometers, I collected them through the filters of a mask, and turned them into the inks for printing the sky portraits above where I encountered the particles.

In a way, we meet here a form of domesticating these particles which invites us to consider the human relationship with fire.

Fire then becomes dependent on us for burning. It remains alive as long as we maintain it. Later, with the Industrial Revolution and the invention of the internal combustion engine, this relationship was amplified.

Yet, if fire allowed us to develop industries, heat ourselves, or cook food, it has also covered the interior of our dwellings with soot, as well as of our lungs. There is always a shadow in the useful work of fire—of which we are often reminded by the anthropologist Marc Higgin—a shadow that represents our involuntary immersion in the environment we are busy transforming.[2] These shadows are emblematic of human attempts to master the world. We, humans, also become a repository for these feral agents as they sediment and find their dwelling in our own bodies.

1 Curated and edited by Anna L. Tsing, Jennifer Deger, Alder Keleman Saxena, and Feifei Zhou, *Feral Atlas: The More-Than-Human Anthropocene*. Stanford University, 2021, https://feralatlas.org/, accessed June 23, 2022.

2 Marc Higgin and Anaïs Tondeur, "The Sky in Us," *Venti, vol 2, no. 1 (2021): Inhale/Exhale,* https://www.venti-journal.com/higgin-and-tondeur, accessed June 23, 2022.

↑ Diana Lelonek, "Ministry of the Environment overgrown by Central European mixed forest," 2017, photography/digital collage

← Anaïs Tondeur, Geranium chinum, exclusion zone, Chernobyl, radiation level: 1.7 µSv/h, *Chernobyl Herbarium,* 2011–22

Špela Petrič: What is feral doesn't have to be formerly domesticated, but can be that which is in excess, which cannot be commodified. Rather than reading ferality within the nature–culture distinction, I would interpret it as an attitude, a moral judgement. The same phenomenon can be considered wild if appreciated or feral if it's not. A cormorant colony is an amazing sight as long as their guano is not in anyone's way, after which they quickly become a nuisance. Their ferality takes over. I'm interested in relational ferality, understanding what is accepted and what is rejected and why. This is why I also consider ferality as a concept to be quite anthropocentric, it has very little to do with the processes it's describing and everything to do with us, humans—it's like naval gazing.

AK: But that's where I think it has power, because it keeps an eye on the human, so it works like a lens. Whereas "wild" seems to suggest being able to find a place that is devoid of human influence, the feral is always about pollution, unwanted effects; it maintains attention on that.

ŠP: I do like the hidden implications of the term, precisely because of this valence of negativity, of that which escapes control.

From the perspective of deeper time and deeper space, in which people are yet another occurrence, these processes we call feral usually appear in transitional spaces, in the absence of something, in this transitional period before the environment becomes super-abundant and stable. If there is no disturbance, diversity seems to "come naturally."

It's a relational term, always in relation to this "other"; it's an aesthetic judgement. The Great Pacific Garbage Patch is now a feral occurrence, it relates to our consumption. And yet in 500 years, all this plastic will have already been used, transformed, incorporated.

It's never going to remain this inert material—it's a source of energy, and bacteria will be the first to know how to use it. If the ruderal space remains uninterrupted, it will become this vivacious ecosystem. What we would aesthetically judge as feral usually takes over in periods of transition, when those redundant relationships have not yet had time to develop. But they will, unless a continuous disruption is present.

In my work with plants, I have come to see plants as the opposite of meek and weak; in fact, they are incredibly potent and definitely turn feral when given the right circumstances. A certain part of our

→ Anaïs Tondeur, Linum
usitatissimum, exclusion
zone, Chernobyl, radiation
level: 1.7 μSv/h, *Chernobyl
Herbarium*, 2011–22

↓ Anaïs Tondeur, Carbon black
particles extracted from the
expedition's masks, 2017–18

↘ Anaïs Tondeur, Fair
Isle Harbour, 26.05.2017,
carbon black level (PM2.5):
12,2 μg/m², carbon ink print,
100×150 cm. *Carbon Black*,
2017–18

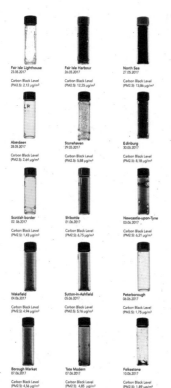

society—farmers, gardeners, the people who maintain infrastructure, and so on—invest huge efforts in keeping undesirable plants at bay.

So how do we position our relationship to plants in order to change this anthropocene-ic worldview, to change the apparent balance of power, when humans as "masters of the environment" are catastrophically failing? For me, one of the ways of doing this is to change the mindset. I am humbled by plants' resilience, adaptability, their seeming ability to resurrect, and their capacity to create conditions habitable for other creatures. Consequently, I see feral landscapes as an expression of plants' power, as a reminder that we humans are blinded by our technological prowess.

If ferality is anthropocentric, what kind of qualities are we ascribing to that which is feral, and for which purpose? What is the hope? What will ferality remedy?

AT: Are there limits to the possibilities opened by ferality? Certain human activities hold such consequences to the power of the living itself that it is annihilated.

Since the explosion at Chernobyl in 1986, the bacteria from the Red Forest no longer decompose organic matter. They were wiped out by the explosion. In these spaces, no more bacterial or vegetal life is possible.

> **AK:** So ferality is an intermediate state, one that is not fundamentally desirable but is linked to a certain hope for a better future with a vivacious, diverse ecosystem. It's not an end-state, but just where we've landed.

ŠP: I think that it can be quite difficult to objectively distinguish a feral art practice from art practice in general. Does feralizing entail imbuing the work process with feral actors, or can a methodology be feral as well? And in the second case, what borders of palatability need to be transgressed to make it so? In the project *Deep Phytocracy: Feral Songs*, I used the term as an aspiration. What I made was a cabaret of tools, taken from radically different contexts of plant–people relations, but remixed into low-tech devices which the participants of the performance use to explore naturecultures. Ferality as a framework allowed for the presumptuousness necessary to take little bits of this discourse, some pagan traditions, and a little bit of industry, a little bit

↑ Špela Petrič, *Deep Phytocracy*, 2018

of what I read in the news that day, and recombine it. Instead of being intimidated by the body of knowledge that surrounds these approaches, I embraced the superficiality of the amateur and played with the spotty knowledge from my research. In this context, feral methodology invoked appropriation out of context, without knowing ahead of time about the consequences or traps as an amateur, as a fool. As means of escaping determining contexts and as an act of playful resistance. In this sense, I understand ferality as an aspirational notion.

DL: My work on the project *Centre for Living Things* was a kind of attempt to, in a way, "feralize" an official research institution. The most interesting part of this project was my collaboration with Poznań Botanical Gardens, Poland. I asked them whether I could use a disused greenhouse at the back of the gardens. I like to think of the entire process in terms of hacking—I hacked the Botanical Gardens. But I think it can also be interesting to think of it as "feralizing." The greenhouse was already abandoned, so was a perfect fit. In a way, the *Centre for Living Things* was made more real, because it was placed inside a genuine research center.

Later, I suggested that their gardens (as generally true of all botanical gardens) didn't really represent what "nature" is nowadays, and that they could open a new department dedicated to waste-plants. I proposed they could also dedicate a department to environments created by these feral agents—post-coal mine slagheaps, wasteland, poisoned water environments, and so on. They agreed to move the *Centre for the Living Things* to the official part of the gardens, which is open to the public. The gardeners started to care for the waste-plants. They treated these waste and plant hybrids the same way as other plants there. Eventually, I created a new department solely dedicated to post-waste habitats. I prepared labels that looked exactly the same as the labels displayed in the rest of the gardens.

I was also looking to create new classifications for these waste and plant hybrids. So, I found new names for these environments: post-footwear habitats, polymer habitats, textile environments, etcetera. One scientist even found a rare species of moss growing on some Styrofoam that I found. Here's a question: what should you do if you find in a forest a piece of Styrofoam, covered in rare, endangered species featured on the Red List? Leave it in the forest, or pick it up and

↑ Špela Petrič, *Deep Phytocracy*, 2018

put it in the bin? This example shows that, today, traditional thinking about nature doesn't apply.

In botanical atlases you can usually find information about preferable habitats for each species.

This described species prefers growing on stones and rocks, near rivers. Perhaps we should extend the traditional kind of classification and say that this particular species also likes growing on Styrofoam. Styrofoam became a pseudo-stone ground for it.

Unfortunately, the director of the Botanical Gardens requested the closure of the exhibition after a year. Despite that, I still think this kind of department dedicated to feral things/areas should be a part of every botanical garden. Right now, I'm looking for a new place for my Centre.

AT: It's stirring to think about an art practice as a feral process. In my work, I am on a quest to invent protocols of attention that deconstruct networks of relations shaped for centuries through a sense of domination, conquest, and mastery. I try to give attention to entities that have been neglected, *invisibilized*, or which simply escape our senses.

I am thus engaged, by means of inventing other stories and other modes of perception, in an exploration of other forms of relation to the world. And this is to think the world together as a network of encounters of the cycles of human existences and those of other agents of the biosphere and beyond. It is also a thinking through our relations to the world in order to better look after it, after us. The French philosopher Bernard Stiegler draws this precise connection between thinking, *penser*, and care, *panser*, as a caretaking of what we inherit from the past and carrying it forward into the future.[3]

3 Bernard Stiegler, *Qu'appelle-t-on Penser? Au-delà de l'Entropocène. 1. L'immense Régression*. Paris: Les liens qui libèrent, 2018.

+ Olga Schubert works as a research consultant for the director of the Haus der Kulturen der Welt (HKW) in Berlin, where she organizes discursive networking and learning formats. Previously, she was part of the curatorial team at hürlimann + lepp Exhibitions and at the Deutsches Hygiene-Museum in Dresden, as well as working in publishing. Amongst her own publications are *Wörterbuch der Gegenwart* co-edited with Bernd Scherer and Stefan Aue (Matthes & Seitz Berlin, 2019), and *100 Years of Now and the Temporality of Curatorial Research* (Sternberg Press, 2019).

+ Gigi Argyropoulou is a theorist, curator, dramaturge, and practitioner working in the fields of performance and cultural practice. She received her PhD from the University of Roehampton and has organized public programs, interventions, performances, exhibitions, and festivals both inside and outside of institutions and publishes regularly in books and journals. She co-initiated the DIY Performance Biennial and Οχτώ/Eight (Critical institute for arts and politics) in Athens and was co-editor of the special issue of *Performance Research* "On Institutions."

+ Mahmoud Al-Shaer is a writer and poet who has acted and volunteered as a writer, content creator, and editor-in-chief and as the executive director for *28 Magazine* for more than four years. He was also a cultural manager at the newly established publishing house Khuta (January 2017–May 2018), and is an initiator and curator of many cultural events and literary readings in Gaza. Al-Shaer received first prize in the University College Competition for Poetry in Gaza (2010) and received second prize in the Palestinian Youth Creativity Competition (2013).

+ Rahul Gudipudi is Exhibitions Curator at Art Jameel and contributes to the research and development of exhibitions and programs at Jameel Arts Centre, Dubai, and Hayy Jameel, Jeddah. He is a co-director at The Story of Foundation, a transdisciplinary learning platform in Goa, and curatorial advisor for *Story of Mind* (2022). Gudipudi's present interests include the politics and future of food and water, socio-technics, lifelong and life-wide learning, as well as translocal transdisciplinary community practices.

+ Vinit Agarwal is an artist, poet, translator, and researcher. Agarwal has contributed to various research projects on Internationalism in East German visual cultures and the politics of film material. He is currently researching the critical intersection of orality and digital archival technologies.

+ Edna Bonhomme is a historian of science, interdisciplinary artist, and cultural writer who earned a PhD from Princeton University. One of her tasks is to mine through the archives and to complicate our understanding of contagion, epidemics, toxicity, and maladies. Through critical storytelling, she narrates how people perceive modern plagues and how they try to escape from them. Her essays have appeared, for example, in *Al Jazeera,* the *Guardian,* and *London Review of Books*. Bonhomme lives in Berlin.

+ Chto Delat was founded in 2003 in St. Petersburg by a group of artists, critics, philosophers, and writers merging political theory, art, and activism. As a collective, it operates in different media such as films, graphics, performance, murals, learning theater, newspaper publications, and radio plays, and through the pedagogic platform The School of Engaged Art.

+ Gilly Karjevsky is a curator of critical spatial practice (Jane Rendell) based in Berlin. Her work always begins with site and situation, teaching and curating programs at the intersection of ecology, ethics of care, and radical pedagogy. She is a founding association member at the Floating University Berlin where she curates Climate Care—a festival for theory and practice on a natureculture learning site, the Urban Practice residency program, and a participatory lexicon process. She is a founding member of Soft Agency—a diasporic group of feminist spatial practitioners, and co-director of 72 Hour Urban Action, with a recent monograph published by *ARCH+*. Currently, she is guest professor for Social Design at the University of Fine Arts Hamburg (HFBK, 2022–23).

+ Agata Kowalewska is an artist and PhD candidate in the faculty of Philosophy at the University of Warsaw. With a special interest in ferality and feralizing as an alternative to rewilding and focus on spaces of human-nonhuman conflict and non-human cultures, she combines research, art, and storytelling. Often working in collaborations, Kowalewska has written on sea fire—toxic glowing dinoflagellates thriving in the dying Baltic, urban wild boars, porcine sex and the politics of purity, hybrid beaver cultures, and bark beetles and why we should allow some trees to die.

+ Diana Lelonek graduated from the Department of Photography in the Faculty of Multimedia Communication at the University of Art in Poznań (PL). She received a PhD in Interdisciplinary PhD Studies at the University of Art in Poznań. She currently works at the Academy of Fine Arts in Warsaw. She uses photography, living matter, and found objects, creating interdisciplinary work that often appears at the interface of art and science. She has participated in several international biennales, festivals, and group shows at: Riga International Biennale of Contemporary Art RIBOCA; Center of Contemporary Art, Warsaw; Kunstraum Niederösterreich, Vienna; Temporary Gallery, Cologne; Tallin Art Hall; Culturescapes Festival, Basel; Musee de l'Elysee, Lausanne; Kunstmuseum Bonn; NTU Centre for Contemporary Art Singapore.

+ Nikolay Oleynikov is an artist, punk, antifascist, and member of the collective Chto Delat and the band Arkady Kots. He is a co-creator and member of other collectives, including the School of Engaged Art, Learning Film Group, May Congress of Creative Workers, and Free Marxist Press. Together with Alessandra Pomarico he curates Free Home University. He is a contributor and editor at *ArtsEverywhere* and author of *Sex of the Oppressed* (2016).

+ Špela Petrič is a Ljubljana- and Amsterdam-based new-media artist, who has been trained in the natural sciences and holds a PhD in biology, and is currently working as a postdoctoral researcher at the Smart Hybrid Forms Lab at Vrije Universiteit Amsterdam. Her artistic practice, which combines the natural sciences, wet biomedia practices, and performance, critically examines the limits of anthropocentrism via multispecies endeavors. Petrič envisions artistic experiments that enact strange relations to reveal the ontological and epistemological underpinnings of our (bio)technological societies. She has received several awards, including the White Aphroid for outstanding artistic achievement (Slovenia), the Bioart and Design Award (Netherlands), and an Award of Distinction at Prix Ars Electronica (Austria).

+ Alessandra Pomarico is an independent curator, writer, and educator working at the intersection of arts, pedagogy, social issues and nanopolitics. She is actively involved in the Ecoversities Alliance towards reimagining education and is a co-founder of the artistic-pedagogical initiative Free Home University. An editor of www.artseverywhere.ca, Pomarico also curated *Pedagogies Otherwise* (2018) and co-edited *What's there to learn?* (2018) and *When the Roots Start Moving: On displacement and belonging* (2021).

+ Irit Rogoff is one of the initiators of the transdisciplinary field of Visual Culture and founder of the department at Goldsmiths, University of London. Her initiatives to establish this new field are led by a belief that we must work beyond bodies of inherited disciplinary knowledge and towards working from conditions. Another strand of Rogoff's work concerns geography, counter cartography and questions of globalization. In publications such as *GeoCultures—Circuits of Art and Globalization* (2009) and *Oblique Points of Entry* (2015) Rogoff explored how critical perspectives and emergent subjectivities form the basis for alternative understandings of the relations between subjects, places and spaces. Together with colleagues she formed the freethought collective in 2011 and the European Forum for Advanced Practices in 2017.

+ **Anaïs Tondeur is a graduate from Central Saint Martins (2008) and the Royal College of Art (2010) in London. Anchored in ecology thought, she searches for a new form of political art working with photography, installation, and video. Crossing natural sciences and anthropology, myth-making and new media processes, Tondeur creates speculative narratives and engages in investigations through which she experiments with other conditions of being to the world. She was awarded the Prix Art of Change 21 (2021) and an Ars Electronica Cyber Arts Honorable Mention (2019), and has presented her work at the Center Pompidou (Paris), La Gaîté Lyrique (Paris), MEP (Paris), Serpentine Gallery (London), and Venice Biennale among others.**

Colophon

Das Neue Alphabet (The New Alphabet) is a publication series by HKW (Haus der Kulturen der Welt).

The series is part of the HKW project *Das Neue Alphabet* (2019–2022), supported by the Federal Government Commissioner for Culture and the Media due to a ruling of the German Bundestag.

Series Editors: Detlef Diederichsen, Anselm Franke, Katrin Klingan, Daniel Neugebauer, Bernd Scherer
Project Management: Philipp Albers
Managing Editor: Martin Hager
Copy-Editing: Mandi Gomez, Hannah Sarid de Mowbray
Design Concept: Olaf Nicolai with Malin Gewinner, Hannes Drißner

Vol. 22: *The New Alphabet School*
Editors: Olga Schubert, Gigi Argyropoulou, Mahmoud Al-Shaer, and Rahul Gudipudi
Coordinator, Managing Editor: Savannah Turner
Contributors: Vinit Agarwal, Edna Bonhomme, Chto Delat, Gilly Karjevsky, Agata Kowalewska, Diana Lelonek, Nikolay Oleynikov, Špela Petrič, Alessandra Pomarico, Irit Rogoff, Anaïs Tondeur
Graphic Design: Malin Gewinner, Hannes Drißner, Markus Dreßen, Lyosha Kritsouk
DNA-Lettering (Cover): Merle Petsch
Type-Setting: Lyosha Kritsouk
Fonts: FK Raster (Florian Karsten), Suisse BP Int'l (Ian Party) Lyon Text (Kai Bernau)
Image Editing: ScanColor Reprostudio GmbH, Leipzig
Printing and Binding: Gutenberg Beuys Feindruckerei GmbH, Langenhagen

Image Credits:

p. 28–29 + 36–37 © Lena Giovazzani
p. 33 Courtesy of Gilly Karjevsky
pp. 40–45 Stills from *OYOYO* by Chetna Vora (Director), 1980,
48 mins and Lars Barthel (Camera), Documents Archive and
conservation: Hochschule für Film und Fernsehen der DDR
(now: Filmuniversität Babelsberg KONRAD WOLF), translation
Cape Verdean Créole into English: Sónia Vaz Borges
p. 48 © Simone Leigh, courtesy of Matthew Marks Gallery
p. 51 © Gerard Garcia
p. 52 Installation view: Domino Sugar Refinery, A project of
Creative Time, Brooklyn, NY, 2014, photo: Jason Wyche, artwork
© Kara Walker, courtesy of Sikkema Jenkins & Co., New York
pp. 55–65 from the archives of Chto Delat, Free Home University,
and Nikolay Oleynikov; photo p. 62 Mikhail Oleynikov
pp. 80–82 Courtesy of Diana Lelonek
p. 84 above Courtesy of Diana Lelonek, lokal_30 gallery
p. 84 below Courtesy of Anaïs Tondeur
p. 86 Courtesy of Anaïs Tondeur
pp. 88, 90 Courtesy of Špela Petrič, photos: Miha Godec

Published by:
Spector Books
Harkortstr. 10
01407 Leipzig
www.spectorbooks.com

© 2022 the editors, authors, artists, Spector Books

Distribution:
Germany, Austria: GVA Gemeinsame Verlagsauslieferung
 Göttingen GmbH & Co. KG, www.gva-verlage.de
Switzerland: AVA Verlagsauslieferung AG, www.ava.ch
France, Belgium: Interart Paris, www.interart.fr
UK: Central Books Ltd, www.centralbooks.com
USA, Canada, Central and South America, Africa:
 ARTBOOK | D.A.P. www.artbook.com
Japan: twelvebooks, www.twelve-books.com
South Korea: The Book Society, www.thebooksociety.org
Australia, New Zealand: Perimeter Distribution,
 www.perimeterdistribution.com

Haus der Kulturen der Welt
John-Foster-Dulles-Allee 10
D-10557 Berlin
www.hkw.de

Haus der Kulturen der Welt

Haus der Kulturen der Welt is a business division of Kultur-
veranstaltungen des Bundes in Berlin GmbH (KBB).

Director: Bernd Scherer
Managing Director: Charlotte Sieben
Chairwoman of the Supervisory Board: Claudia Roth MdB
Federal Government Commissioner for Culture and the Media

Haus der Kulturen der Welt is supported by

 Minister of State for Culture and the Media

 NEU START KULTUR

 Federal Foreign Office

First Edition
Printed in Germany
ISBN: 978-3-95905-660-1

Vol. 4: *Echo*
Editors: Nick Houde, Katrin Klingan, Johanna Schindler
Text: Lisa Baraitser, Louis Chude-Sokei, Maya Indira
 Ganesh, Wesley Goatley, Xavier Le Roy, Luciana Parisi,
 Sascha Pohflepp, Sophia Roosth, Gary Thomlinson
ISBN: 978-3-95905-457-7

"If sound is birth and silence death, the echo trailing into infinity can only be the experience of life, the source of narrative and a pattern for history." Drawing on Louis Chude-Sokei's metaphorical, political, and technopoetic investigations, this volume experiments with how the echo of past ideas of life and form has brought forth the technologies and lifestyles that our contemporary world is based on. The essays, conversations, and artist contributions delineate a variegated array of technologies, creating an image of their past and their future potentials.

Vol. 5: *Skin and Code*
Editor: Daniel Neugebauer
Contrib.: Alyk Blue, Luce deLire, i-Päd, Rhea Ramjohn, Julia
 Velkova & Anne Kaun
ISBN: 978-3-95905-461-4

Just as physical violence leaves its marks on the skin, conceptual violence is written into interfaces via algorithms—in the
form of biases turned into pixels, as discrimination implanted in
memes in secret chat groups. The coding and decoding of body
surfaces and interfaces is contingent on a whole host of norms.
Yet these are not fixed: rather, they combine to create a matrix
of tastes, cultural influences, technical conditions, and physical
possibilities. The essays in this volume produce an interdisciplinary noise between surface structures and a selection of cavities: surfaces, skins, and interfaces are injured, gauged, altered,
or remedied.

Vol. 6: *Carrier Bag Fiction*
Editors: Sarah Shin, Mathias Zeiske
Contrib.: Federico Campagna, Dorothee Elmiger, Ursula
 K. Le Guin, Enis Maci a.o.
ISBN: 978-3-95905-463-8

What if humanity's primary inventions were not the Hero's spear but rather a basket of wild oats, a medicine bundle, a story. Ursula K. Le Guin's 1986 essay *The Carrier Bag Theory of Fiction* presents a feminist story of technology that centres on the collective sustenance of life, and reimagines the carrierbag as a tool for telling strangely realistic fictions. New writings and images respond to Le Guin's narrative practice of worldmaking through gathering and holding.

Vol. 7: *Making*
Editors: Nick Houde, Katrin Klingan, Johanna Schindler
Contrib.: Luis Campos, Maria Chehonadskih, Reece Cox, Ana
 Guzmán, Hao Liang, Hu Fang, Elisabeth Povinelli,
 Kaushik Sunder Rajan, Sophia Roosth
ISBN: 978-3-95905-465-2

Who produces what, and how? What tools and technologies, what values and intentions are fed into the process? What part do power and control play in the context of semi-autonomous technologies that will shape our future world? The book's essays, conversations, and artist contributions focus on the practices and politics of production as a response to our contemporary processes of planetary transformation.

ISBN: 978-3-95905-660-1

Spector Books